The Museum of Rome tells the story of the city
Concise guide

©
Copyright reserved

Comune di Roma

Gangemi Editore
Piazza San Pantaleo 4, Rome
www.gangemieditore.it
No part of this publication
may be stored on a computer,
photocopied or in any way
reproduced without the due
authorisations.

ISBN 88-492-0395-0

Comune di Roma
Sovraintendenza ai Beni Culturali
Museo di Roma

The Museum of Rome
tells the story of the city
Concise guide

Gangemi Editore

COMUNE DI ROMA

Assessorato alle Politiche Culturali
Assessore
Gianni Borgna

Sovraintendenza ai Beni Culturali
Sovraintendente
Eugenio La Rocca

Musei d'arte medievale e moderna
Dirigente
Maria Elisa Tittoni

Concise guide edited by
Rossella Leone
Federica Pirani

Texts by
Tiziana Giustozzi
Rossella Leone
Anna Lio
Anita Margiotta
Emiliana Ricci
Chiara Ronzio
Teresa Sacchi Lodispoto
Simonetta Tozzi

Editing
Margherita Ferrucci

Bibliography
Cinzia Salvi

Graphic design and pagination
Raffaella Ottaviani

Iconographic archive
Simonetta Sergiacomi
Patrizia Savio
in cooperation with
Stefano Bertozzi
Roberto Lucignani
Alfredo Valeriani

Photographs of the rooms
Antonello Idini

Restorations of the new works on exhibition
Paintings
Cristina De Gregorio
Fiorenzo Perfetti
Graphic and photographic works
Ombretta Bracci
in cooperation with
Giulio Liberotti
in cooperation with
Simona De Cubellis
Design
Enzo Serrani

Translation
Globe (Foligno)

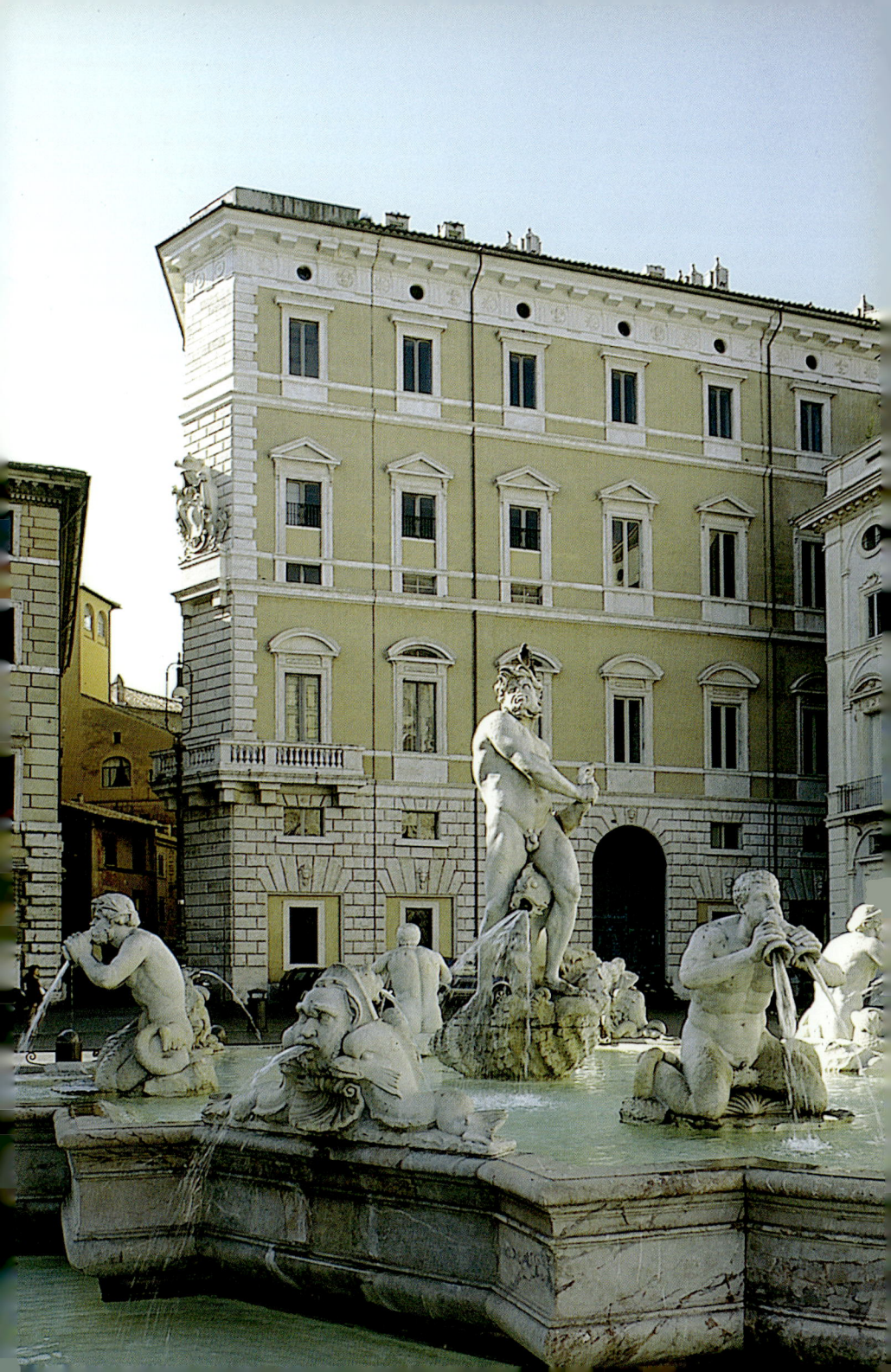

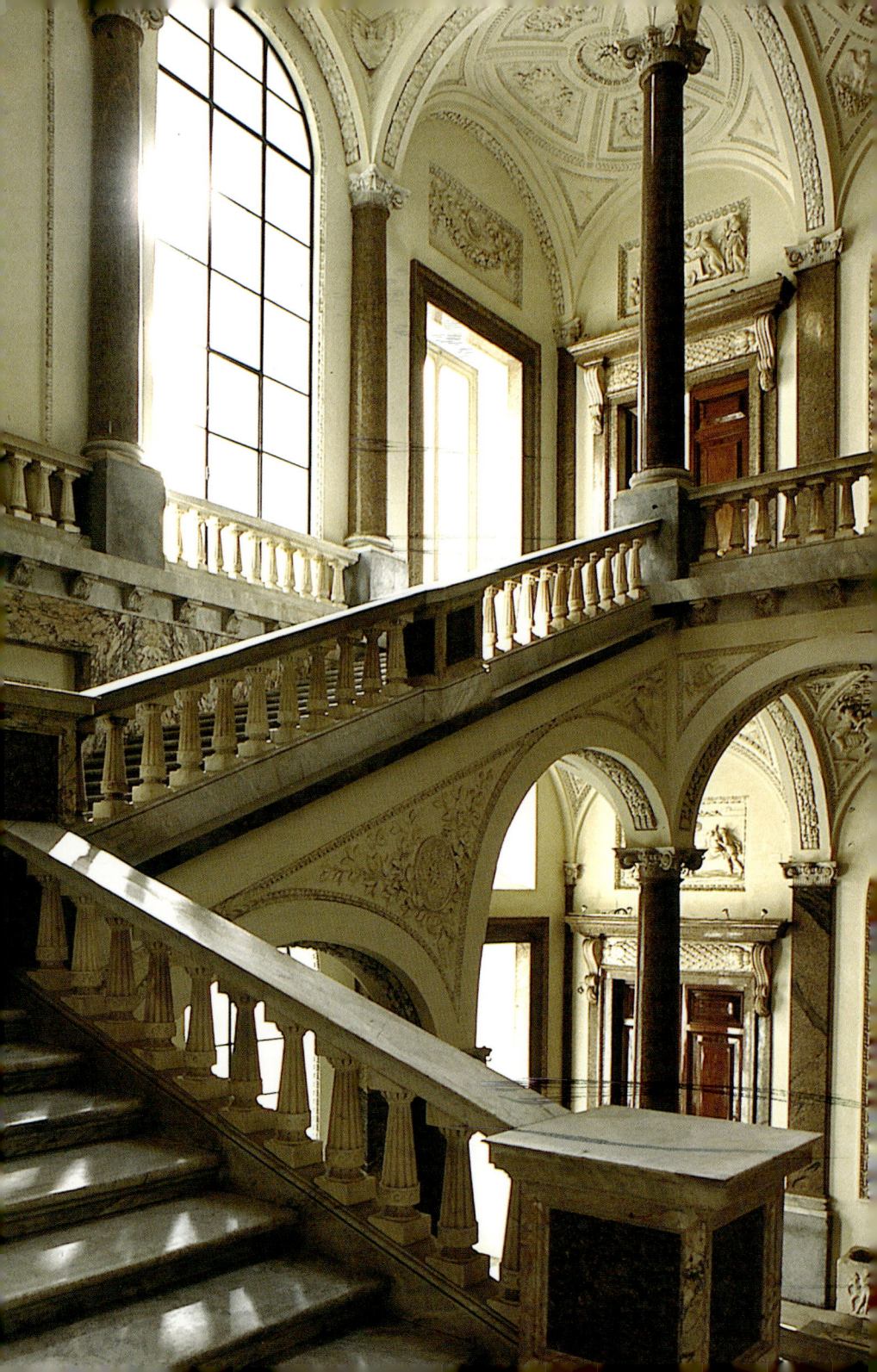

The Museum of Rome

With changing fortunes, marked by historical events and by the evolution of its original inspiring criteria, the complex and, in some ways, troubled history of the Museum of Rome unravelled throughout the twentieth century.
On the other hand, all the difficulties and ambiguities which would characterise its journey were already implicit in the ambitious task of wanting to set up a Museum which was able to reconstruct in an exhaustive manner, into a single large fresco, the secular history of Rome, from the city of the popes to the young capital of Italy.
In fact, at the time of the inauguration of the Museum of Rome in 1930, Antonio Muñoz, the then Director of Antiquities and Fine Arts of the Governorship of Rome, whilst proudly claiming responsibility for the much awaited implementation and layout of the Museum, felt the need to justify its institution in a city like Rome so richly endowed with Museums which were "already so great and famous and celebrated throughout the world; to which flock pilgrims of the ideal and people from every country; where those masterpieces are housed which all nations envy us".
In harmony with the cultural climate of his time, in which the remembrance of the profound transformation experienced by the city in becoming the capital of Italy was still fresh, he identified the conservation of the memory of the city's life, traditions and image as the justification for the existence of the Museum of Rome. It was intended to be, according to Muñoz, "the urn of sweet nostalgias, the refuge of our dreamy soul, the oasis where we Romans will be able to recreate our spirit, among the beloved small things of the life that once was!"
In effect, this first stage in the Museum's life was entirely addressed at elegising and, at the same time, documenting, in a desire to fix and hand down to the collective imagination of posterity the beauty and the poetry of the Rome which had vanished or which was vanishing in the town-planning and building fervour of the Fascist period.
The outbreak of the Second World War forced the closure of the Museum, which at that time was located in the great building on Via dei Cerchi whose façade bore the proud inscription "Palace of the Museums of Rome". When the Museum was reorganised, after the war, the need was felt to find premises which, in terms both of historical and architectural prestige and of location, would fully correspond with the quality and the importance of the collections and would allow for their more extensive and complete development. Not without a "tough fight", as Antonio Maria Colini recalls, the Museum of Rome obtained the eigh-

teenth-century Palazzo Braschi, thus being able to reopen to the public in 1952 based on a layout in three large sections, topography, history and customs, which, broadly speaking, complied with the configuration of the 1930s.

This was a very successful period for the Museum due the public's goodwill and to the constant and valuable increase of its collections, thanks in part to the generous activity of the "Associazione degli Amici dei Musei" which encouraged important bequests and donations.

In fact, by the early 1960s it had already become necessary to proceed with a modification of the exhibition set-up, both due to the need to include the new acquisitions in the original itinerary and due to an alteration in museological sensitivity; the desire to provide documentation was refined with the intention of giving preference at exhibition level to the aesthetic quality of the materials, which were also arranged according to more precise chronological criteria.

However, the arrangement arrived at was "an arrangement of convenience, suited to the rooms and to the available material rather than being systematic and rational", as Carlo Pietrangeli noted.

In the subsequent decades, the enrichment of the collections with works of considerable historical-artistic value and the significant importance of the creation of the Communal Prints Studio and the Communal Photographic Archive were not expressed, however, in a contextual reflection on the need to critically re-examine and update the inspiring criteria of the Museum in the light of the new cultural expectations dictated by the profound changes in methodology and the social context. Those same years also saw the start of the slow but inexorable structural decline of Palazzo Braschi, which in 1987 led to its closure.

Having finally succeeded, after fifteen years, in partially re-opening the Palace, it was necessary to decide exactly what to offer to the public of the Museum's rich collections, what selection of its vast and subdivided heritage and which interpretation should be given preference to: whether to propose a presentation of works which would represent the definitive, albeit limited, layout of the museum of Rome or whether to present a chronological anthology, from the Middle Ages to the twentieth century, of the artistically and historically more important and significant exhibits.

Neither of these solutions seemed convincing, the former because, precisely because of its partiality, it would have been fragmentary and incomplete and therefore difficult for the public to understand, the latter because to a certain extent it would have negated the extraordinary capacity of the Museum to recount and evoke the many possible "histories" of Rome.

The Museum of Rome, on account of the richness of its collections, also

characterised by a remarkable variety of artistic techniques, can in fact be considered as the most significant institution for our knowledge of social history and artistic activities in Rome from the Middle Ages to the beginning of last century.
The narrative dimension, complying with the first and fundamental documentary vocation of the Museum, is the hinge around which its numerous and variegated collections can revolve; by combining their intrinsic value with the narration's potential for suggestion, their significances are multiplied and a fascinating interplay of routes is made possible through the myriad incidents, situations, events, vicissitudes and personalities forming the historical and social secular fabric of the city. The current proposal consists of an interpretation supplemented with extracts of several chapters in the city's history; this, although not intentionally wishing to herald the definitive configuration of the Museum, emblematically foreshadows its future potential and the role which, once the works of the second lot are concluded, it will be able to play in the Roman museum system.
From the very extensive range of narrative plots which Rome and the Museum might suggest, a themed scenario has been chosen which, through protagonists, events and place, availing itself of the multitude of artistic techniques, might offer the visitor a sequence of suggestions about life and society in Rome between the seventeenth and nineteenth century according to an itinerary which is not strictly chronological but plays rather on cross-references and assonances.
The precious spectacular backdrop and the noble prologue of the exhibition is Palazzo Braschi itself, commissioned by Pope Pius VI as a residence for his nephew Luigi and for his wife Costanza Falconieri.
The recent restorations have restored splendour to the noble architecture designed by Cosimo Morelli at the end of the eighteenth century, to the majestic elegance of the atrium and the staircase, to the refinement of the stuccoes, of the paintings and the decorative parts. In particular, the decoration of the staircase, of daring spatial articulation to which baroque reminiscences are not unrelated, is a testimony of great significance to the classicist taste tinged with the antiquarian erudition of the epoch. In the use of the very beautiful red granite columns from the Portico of Caligula, crowned with elegant Ionic capitals adorned with the heraldic motifs of the Braschi coat of arms, the red granite pillars originating from the Antonine column, in the niches adorned with statues – the last surviving examples of the famous collection of the family's classical sculptures – and, finally, in the exuberant profusion of stuccoes which cover ceilings and walls inspired by the myth of Achilles, the work of Luigi Acquisti, it is the Ancient which triumphs, the sign and measure of pomp and power.

Metaphorically closing the prologue, the entrance hall on the first floor displays canvases by Gavin Hamilton depicting *Venus offering Helen to Paris, The Rape of Helen* and *The Death of Achilles,* once in the Villa Borghese. These paintings, of great decorative effect, coeval with the *Oath of the Horatii* by David, are among the works which, precisely during the pontificate of Pius VI, inaugurated the great Roman neoclassical period.

The due homage to Pius VI, who was responsible for the palace, is made more complete by the restoration to their original setting of the two busts of the pope and of the cardinal Romualdo Braschi Onesti, respectively the work of Ceracchi and Penna, recently acquired from the family and exhibited to the public for the first time.

The narration shifts backwards in order to present the papal court in terms of its protagonists and events, between the seventeenth and nineteenth century, in a sequence of images of popes and cardinals, of celebrative and allegorical pictures, drawings and engravings which reconstruct the sumptuous, colourful and vibrant portrait of the papal city.

The Campidoglio, seat of the city's administration, where, even if only with symbolic powers, resided the Roman magistracies of the Senator and the Conservators, is recalled by the *Portrait of Senator Nicola Bielke* and by the costumes of the Senator and his page.

Over the centuries, Rome has offered artists an inexhaustible subject, with its piazzas, its famous ancient monuments, its circle of villas and its panoramic views; the view of various places – interweaving everyday life and historical events – has often acquired the twofold value of identifying both the city and its urban scenarios. For this reason we have placed side by side, for example – deliberately playing on a double register – *The Arrival at the Quirinal of the Veneto Ambassador Nicola Duodo* and the *Arch of Titus* by Viviano Codazzi, and the *Papal Blessing in Saint Peter's Square* by Ippolito Caffi and the extraordinary *View of Rome from Monte Mario,* also by Caffi.

The story of the city concludes with the recollection of that particular cultural climate which between the eighteenth and nineteenth century made Rome the cosmopolitan capital of artists and educated travellers, in which the evocation of classical antiquity nurtured an extraordinary microcosm of the ancient. To complete the outline of Roman society, a small collection of clothes of the period introduces the fashion codes of the ruling class.

The second floor is dedicated to the patronage of several great Roman families of which the Museum of Rome preserves important examples; in an excursus which goes from the seventeenth to the nineteenth century, by means of the variety of artistic techniques and themes, the succession of the various commissioners unravels, marked by changes in taste and the logics of social representation.

The Barberini are represented, not only by the busts by Mochi, by Ottoni and Cametti and other works, but also by the expressly restored Baldachin Ceiling decorated with the heraldic bees of the house woven to a design by Pietro da Cortona in the family tapestry factory and by the Medal Showcase dating back to the first half of the seventeenth century with the celebrative medals of the pontificate of Urban VIII organically exhibited for the first time.

With the Rospigliosi collection, one of the Museum's first important acquisitions (1931-1932), it is possible to re-evoke the rhythms of life, marked by festivals and anniversaries in the Esquilino residence and on the Maccarese estate, of a noble family in the course of the eighteenth century.

The model for the Rospigliosi Chapel in San Francesco a Ripa by Nicola Michetti documents, on the other hand, the traditional custom of Roman families to commission their own aristocratic chapel in the city's churches.

In the course of the nineteenth century Roman patronage experienced its last splendid period with the Torlonia commissions. In particular, the Museum houses some extraordinary tokens linked to the decoration of the destroyed Palazzo Torlonia in Piazza Venezia, of the Apollo Theatre demolished in 1889 to make way for the construction of the Tiber embankments and of the Villa di Castel Gandolfo. The refined elegance of the stuccoes and paintings, in the so-called "Alcove", emblematically closes the re-evocation of the magnificence of the Torlonia residences and of their role in Roman artistic culture.

The Giustiniani Bandini and Brancaccio collections aim to bring into focus Roman aristocratic society through a sequence of portraits which, from the exquisite smoothness of the bust of Maria Massani by Thorvaldsen, passes on to the sumptuous and charming manner of Gai, an efficacious example of the eclectic taste of the young capital of Italy.

The last room of the exhibition is dedicated to the transition from papal Rome to Rome the capital of the Kingdom of Italy, with a targeted selection of the rich and complex fund of the Communal Photographic Archive. As compared to the more usual views of the city, it has been preferred to select several significant portrait examples as a logical continuation of the portraiture of the century, which in the recent photographic technique had found new results and a wider clientele.

The works presented constitute only a small cross-section of that mine of figurative sources housed in the Museum, a priceless heritage for those who wish to study or simply become acquainted with the artistic and social secular history of Rome.

<div align="right">Maria Elisa Tittoni</div>

Forewords

In the graphics descriptions the abbreviations inv. and eng. indicate the inventor of the subject and the engraver of a print.

ITINERARY – First Floor

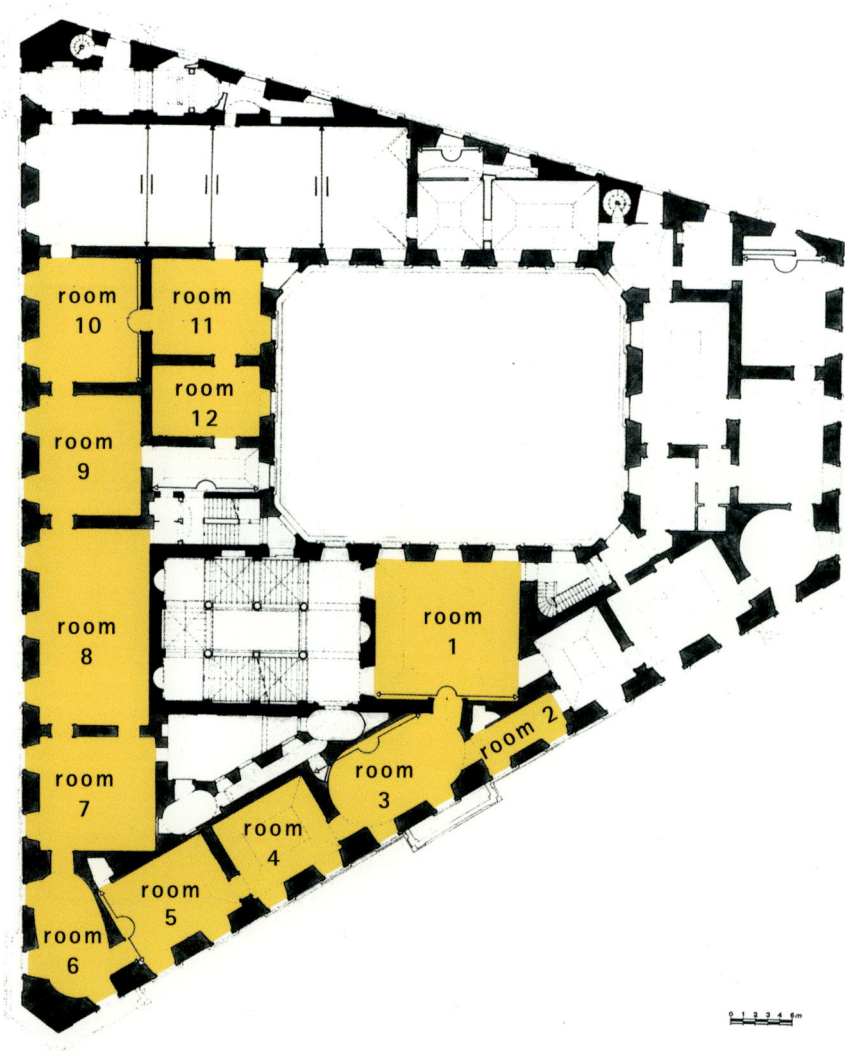

Room 1 - Histories
Pius VI: the city of antiquities and the great works

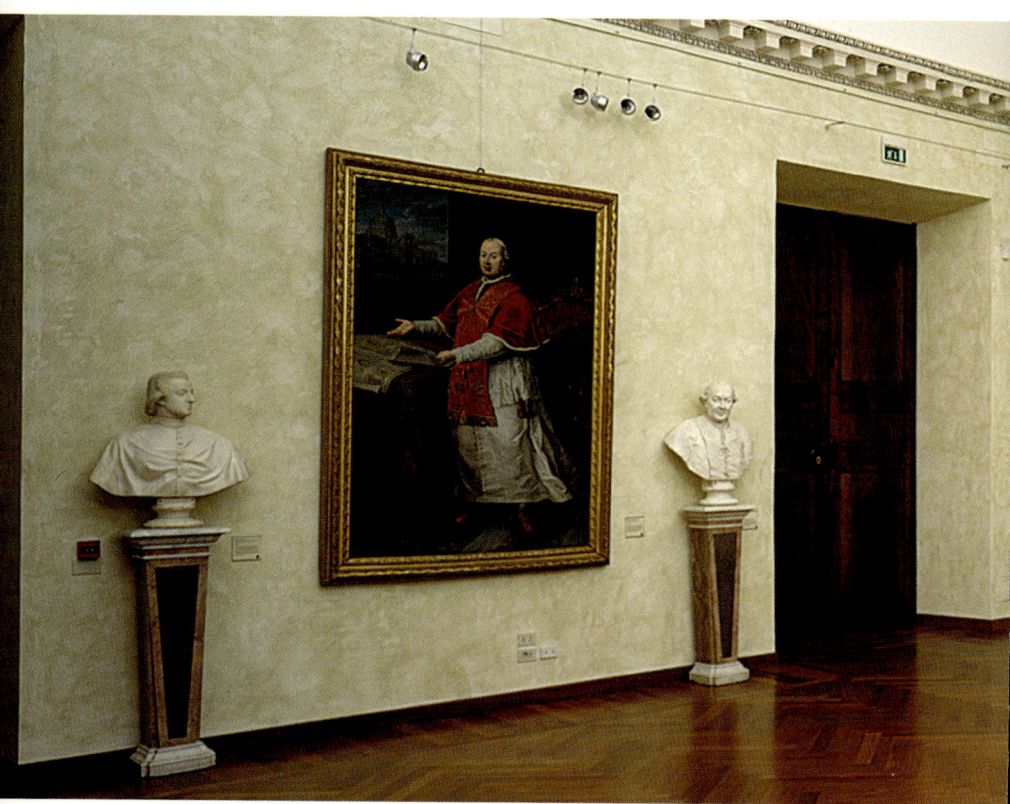

On the eve of the radical political changes which, with the Revolution of 1789 and the subsequent occupation of Italy by the French, would irreversibly alter the historical and cultural conditions of Rome, capital of the catholic world, the relative tranquillity of the years of the reign of Pius VI Braschi, elected in 1775 and who died in exile in 1799, allowed for the final establishment of the papal city's cultural supremacy.

It was at this tail-end of the century that a courtly and refined art achieved its highest expressions, based on the harmony of forms of the classical tradition and of the art of Raphael which for decades would influence European culture. At the same time, the pope, aspiring to be identified with his Renaissance predecessors, promoted the realisation of magnificent works and renewed, for the last time in the church's history, the practice of showing nepotism towards his family. Palazzo Braschi in Piazza Pasquino, built for his

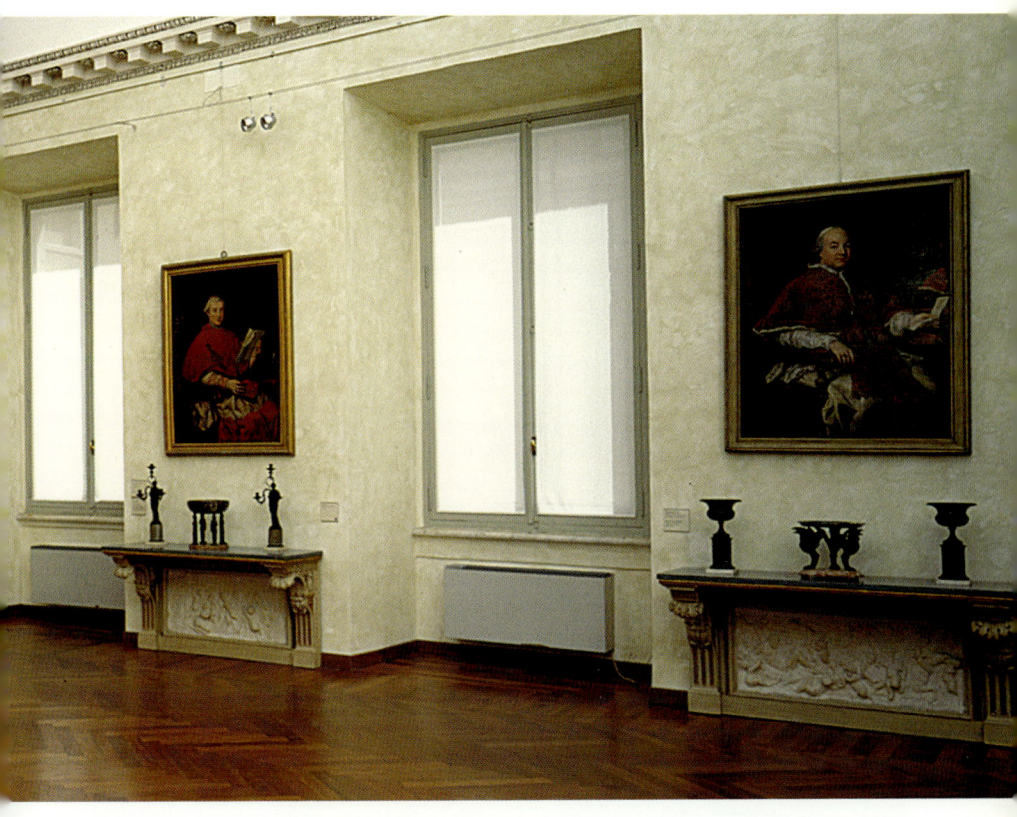

nephew Luigi Braschi Onesti, is the most grandiose example of this.
The interest in the ancient, inspired by the vision of Johan Joachim Winckelmann and fed by the intensified activity of excavating and trading in archaeological finds, led to the expansion of the Vatican Antiquities Museum, with the completion of the new Pio Clementino Museum.
The circulation of publications illustrated with engraved reproductions of works of antiquity, helped to establish a repertoire of normative models and themes for contemporary figurative culture, one of the most complete expressions of which can be found in the Villa Borghese decorative cycle.
The scenes painted for the *Room of Helen and Paris* in the villa's Casino by the Scottish artist Gavin Hamilton, at the beginning of the eighties, are one of the most significant eighteenth-century interpretations of classical composure and monumentality, combined with the grace of Raphael.

Room 1 - Histories
Pius VI: the city of antiquities and the great works

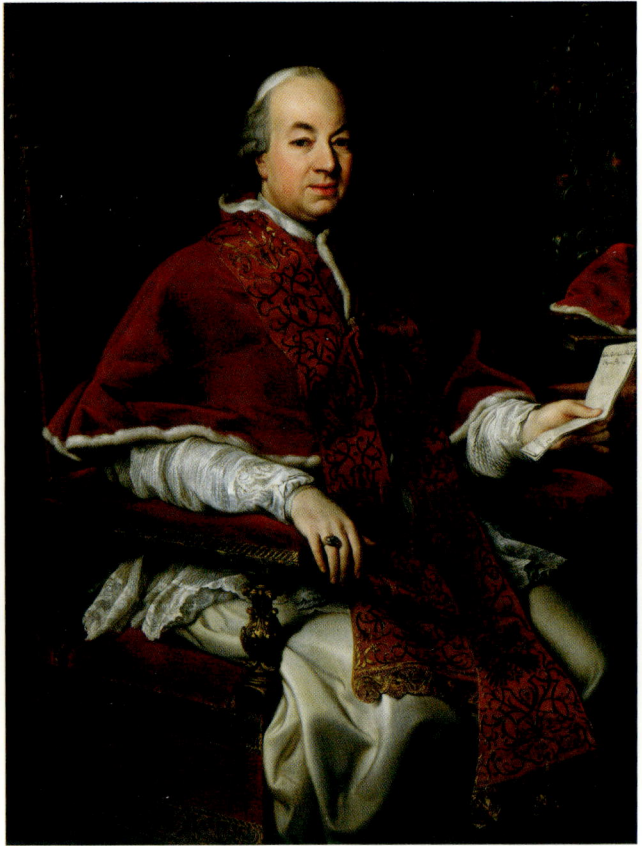

Pompeo Girolamo Batoni (copy)
Portrait of Pius VI, 1775
oil on canvas, 135 x 98 cm
MR 5669

This painting is considered to be a studio copy after the portrait which was commissioned from Pompeo Batoni in 1775, immediately after the election of Pius VI Braschi. Painted by the most successful portrait artist of the time, this work served as the official image of the pope and was replicated on more than one occasion.

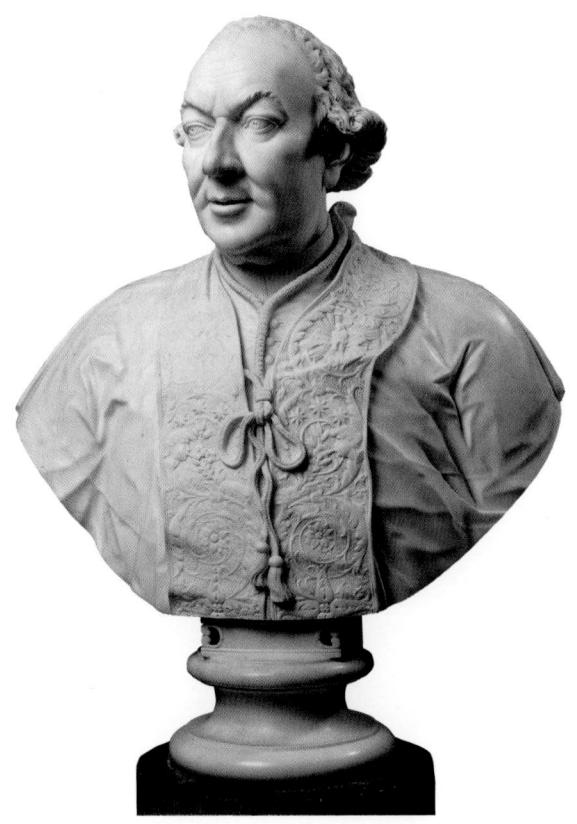

Giuseppe Ceracchi
Pius VI, post 1788
marble, 91 x 71 x 37 cm
MR 45699

This bust can be referred, albeit with variants, to the prototype made in 1788 by the sculptor Giuseppe Ceracchi and praised by the contemporary press as " better than any other executed hitherto". The bust signed and dated 1790, at present conserved in Genoa in the Palazzo Bianco Gallery, derives from the same original.

Room 1 - Histories
Pius VI: the city of antiquities and the great works

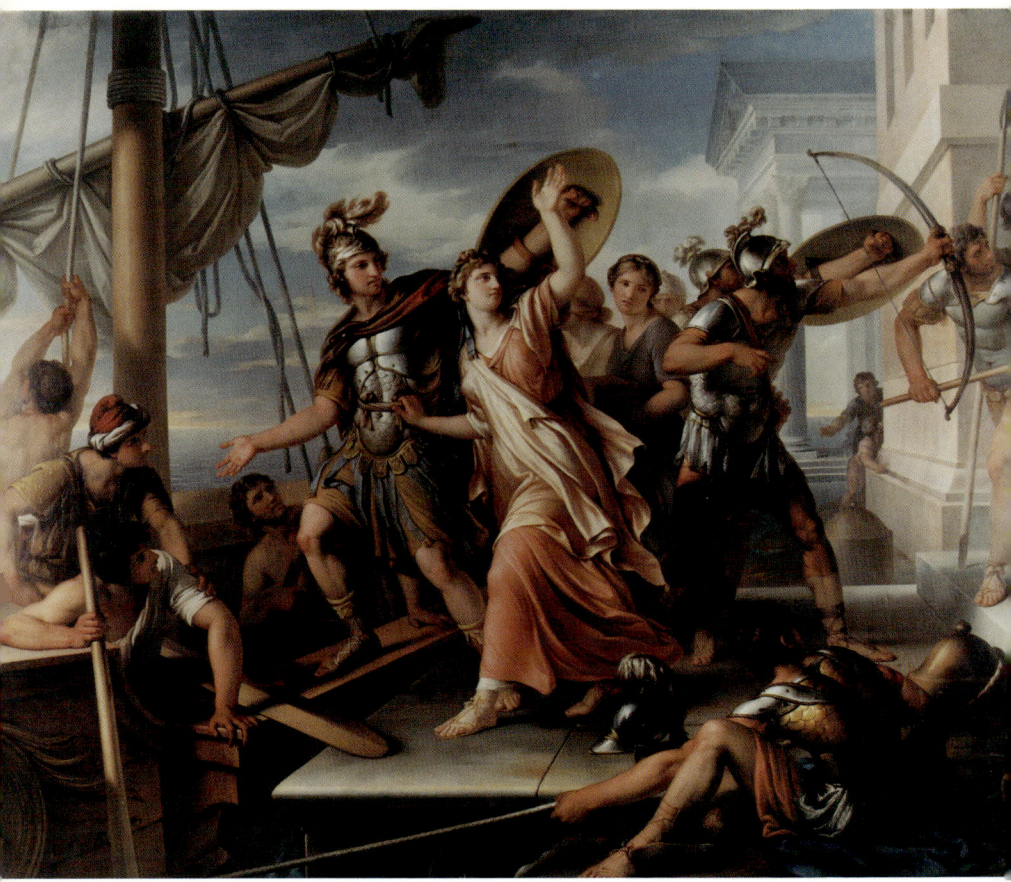

Gavin Hamilton
The rape of Helen, 1784
oil on canvas, 306 x 367 cm
MR 3797

Gavin Hamilton
The Death of Achilles, 1785
oil on canvas, 333 x 288 cm
MR 3798

These two paintings, together with *Venus offering Helen to Paris* (not reproduced) are part of a cycle of eight canvases dedicated to the *Stories of Helen and Paris* and originate from the Palazzina at the Villa Borghese. A critical, sentimental and original reinterpretation of the Homeric themes, they represent the culminating moment of a research begun by Gavin Hamilton about twenty years earlier, with a series of paintings depicting scenes drawn from the Iliad.

Room 1 - Histories
Pius VI: the city of antiquities and the great works

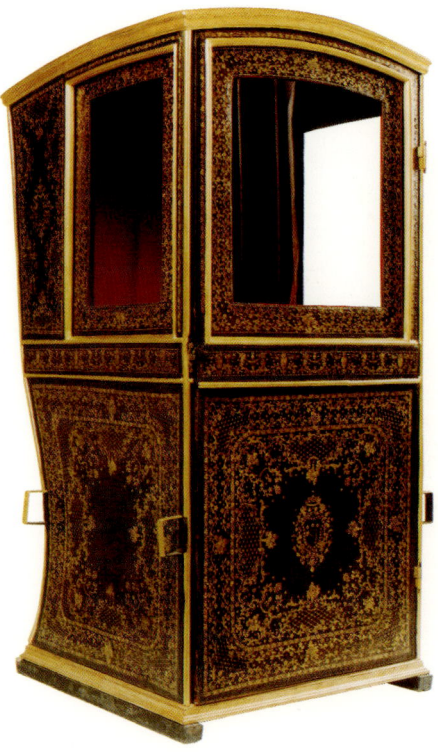

Made in Rome
Braschi sedan chair, 1780-1790
wood, gold-tooled red leather
164 x 76 x 86 cm
MR 1471

The sedan chair, which belonged to the Braschi family, made of red leather, known as Roman "rosolaccio" [corn poppy] or "Roman morocco leather", has a rich gilded tooled decoration in which the family coat of arms is framed by motifs from the rococo repertoire, which also persists in the coeval leather Roman bindings.

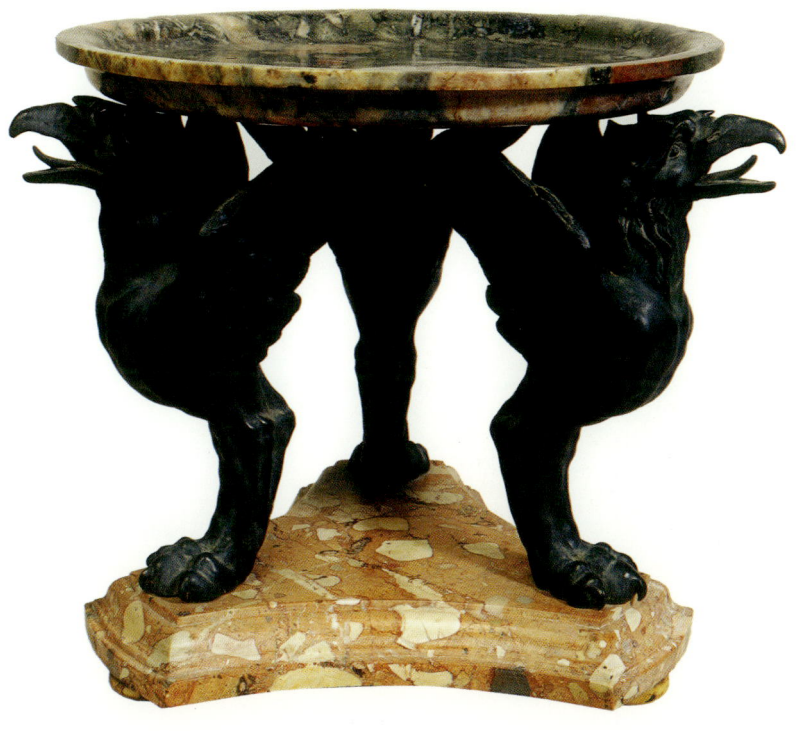

Luigi Righetti (attributed)
Tripod with hippogriffs
late eighteenth century – first quarter of the nineteenth century
patinated bronze, green African marble
height 30 cm; Ø 31 cm
MR 5821

The marble plate supported by three hippogriffs recalls a typology which was very common in neoclassical culture and used on more than one occasion in the production of the successful goldsmiths and casters Luigi and Francesco Righetti.

Room 1 - Histories
Pius VI: the city of antiquities and the great works

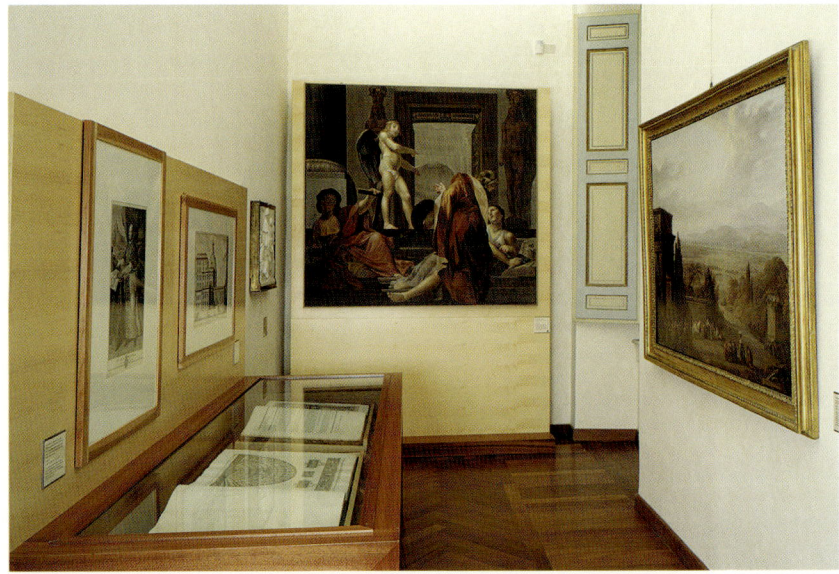

Pius VI's aspiration to follow in the footsteps of the Renaissance popes was expressed in numerous town-planning and architectural initiatives, including the realisation of the Vatican Sacristy. The idea of a new sacristy dated back to the pontificates of the previous century and the project had been successively entrusted to various prestigious architects, from Carlo Maderno, to Gian Lorenzo Bernini, and to Filippo Juvarra, during the pontificate of Clement XI Albani. Pius VI succeeded in constructing the new building which, commissioned from Carlo Marchionni, was completed between 1776 and 1784. However, Pius VI's perhaps most celebrated work was the ambitious project to reclaim the Pontine Marshes, whose first successes, at the beginning of the eighties, were recorded by paintings and engravings and celebrated by maniloquent poetic texts in which the pope was exalted as the person responsible for a renewed golden age. Yet despite the enormous technical and economic resources set aside for the enterprise by Pius VI, the results were extremely incomplete. The debatable administrative decisions did in fact lead to the enrichment of the pope's family through the granting in emphyteusis, at ridiculously low rents, of almost all the expropriated and reclaimed lands. On the other hand the organic unity of the undertaking, which included the reorganisation of the territory with the construction of new roads, bridges, post houses, warehouses and dwellings, can be considered as being in harmony with the more general trend of the agricultural economy of the time towards the significant increase of land put under crop.

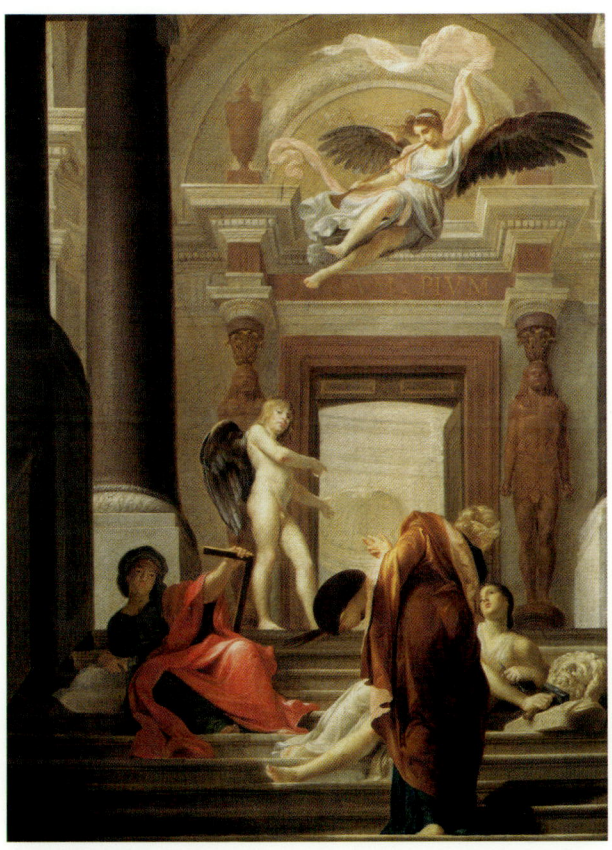

Bernardino Nocchi
Allegory of the Pio Clementino Museum, ca. 1788
oil on canvas, 61 x 44 cm
MR 1107

This painting is a sketch for the decorations of the apartment in the Palazzo della Consulta belonging to cardinal Romualdo Braschi Onesti, nephew of Pius VI, elected cardinal in 1786. The allegory celebrates the completion of the Museum of Antiquities in the Vatican, known as the Pio Clementino Museum, founded by Clement XIV and extended by Pius VI between 1779 and 1784.

Room 2 - Histories
Pius VI: the city of antiquities and the great works

Abraham-Louis-Rodolphe Ducros
Visit of Pius VI to the Pontine Marshes, 1786
oil on canvas, 122 x 170 cm
MR 41388

This painting, a historical-celebrative representation of the venture to drain the Pontine Marshes undertaken at the behest of Pius VI in 1777, reveals, in the spacious landscape background, the Swiss artist's attention to topographic precision and his typical sensitivity to atmospheric qualities, merits which guaranteed his success with an Anglo-Saxon clientele.

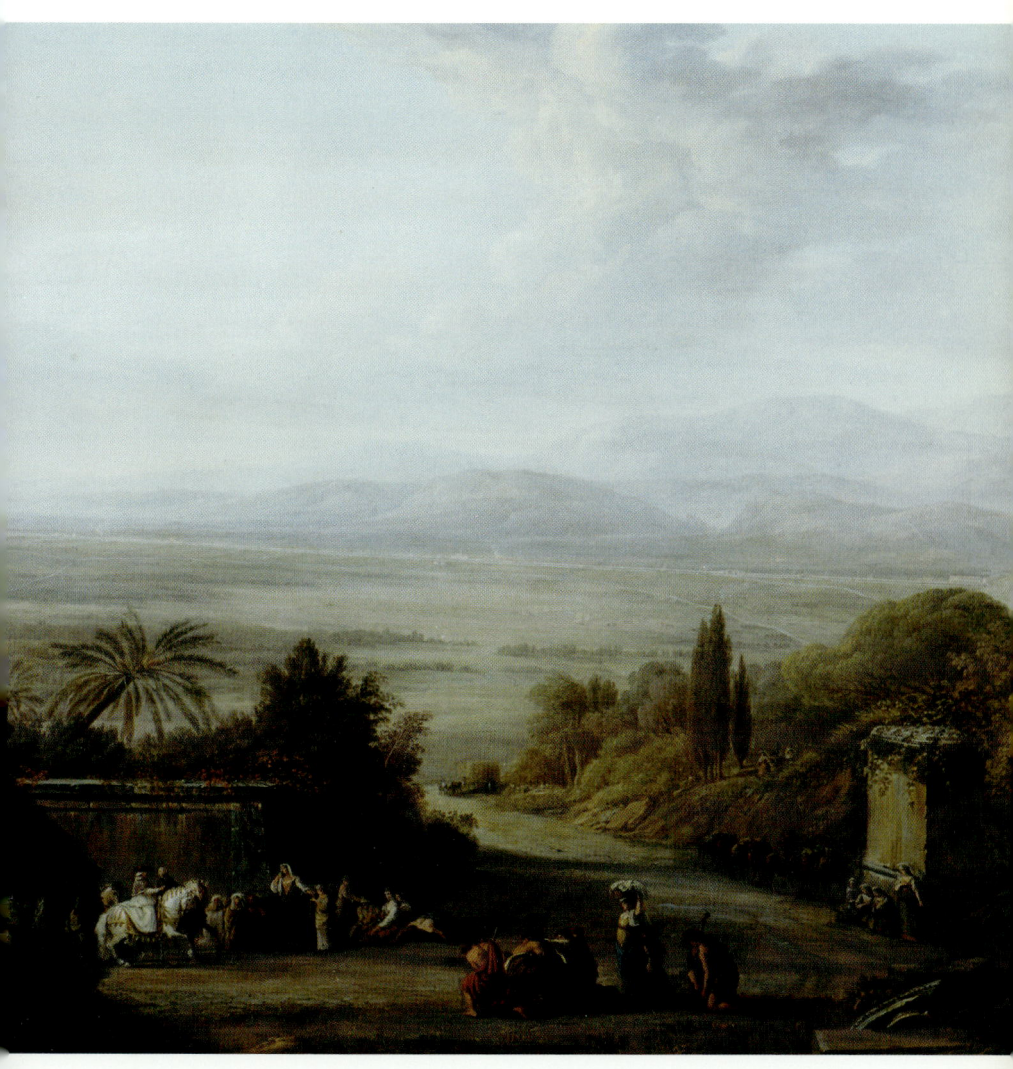

Room 3 - Histories
The papal court

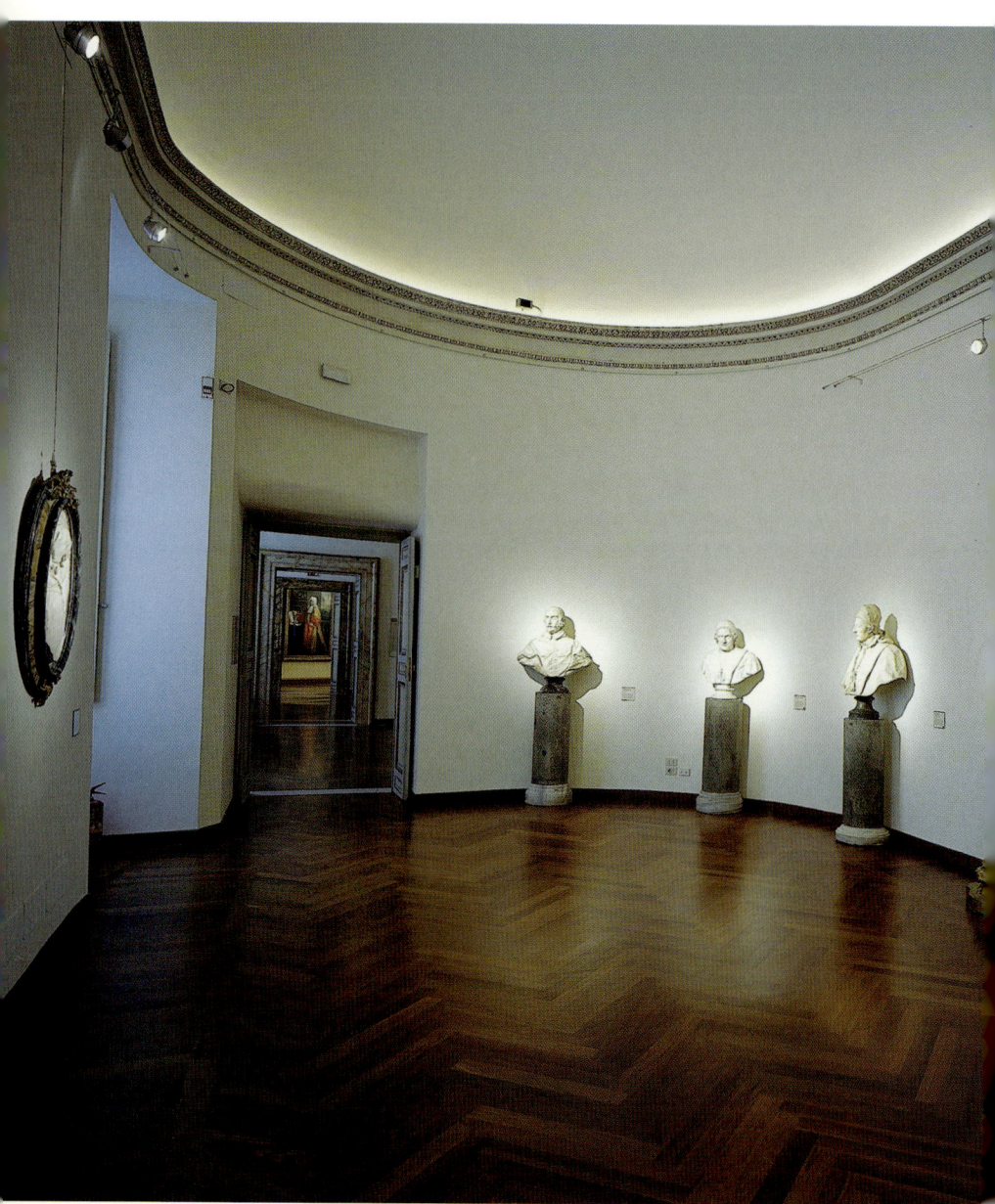

26

The economic and political life of the papal city was characterised by an ultra-conservatism which persisted over the centuries. At the apex of the social structure, within which the hierarchy of privileges was rigidly fixed, the nobles and the high clergy monopolised agricultural and financial incomes, leaving little room for the development of a class of artisans and merchants. The church's values of universality allowed the papal government a material and spiritual control of society, with direct moral and religious pressures on the individual. This led to a portrait production in which prevailed, from the sixteenth century, the definition of public images which recorded the characteristic signs of the exercise of power or of social prestige and underlined the awareness of the close individual-State relationship. In the seventeenth century, the extraordinary portraits painted by Gian Lorenzo Bernini surpassed any previous conquest of verisimilitude, not only in physiognomic terms, but also in terms of expression and movement, and influenced the entire subsequent production of pictures and sculptures. Psychological introspection and vividness, controlled by a search for an idealising equilibrium and harmony, can be found in the busts of popes and prelates by François Du Quesnoy, Domenico Guidi and Filippo Della Valle. Around a century later, a refined realism, aimed at defining the typology of a venerable old age, emerges in the bust-portrait of Clement XIV, painted by Christopher Hewetson at the beginning of the 1770s.

Room 3 - Histories
The papal court

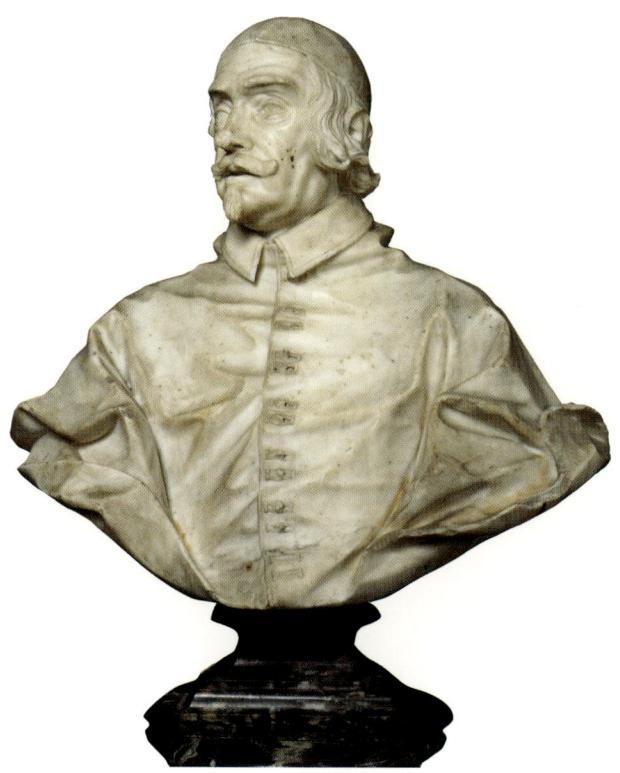

Domenico Guidi (attributed)
Bust of cardinal Pietro Ottoboni senior, 1670-1680
marble, 71 x 75 x 43 cm
MR 45681

Cardinal Pietro Ottoboni senior (Venice 1610-Rome 1691) was elected pope in 1689 under the name of Alexander VIII. His pontificate was characterised by a strongly nepotist internal policy and by the defence of the authority of the Holy See in France. A participant in the culture of the rising Arcadia Academy, in 1690 he acquired the library of Christina of Sweden.

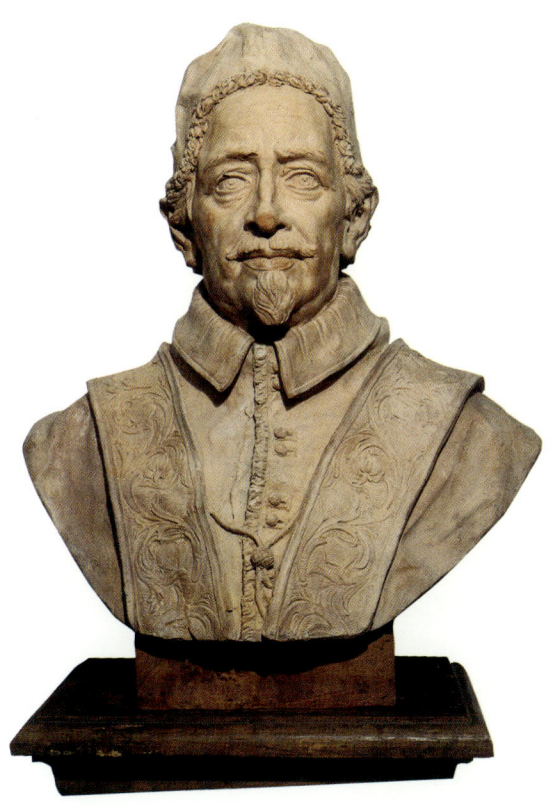

Domenico Guidi (attributed)
Bust of Innocent XII, 1694-1696
terracotta, 63 x 56 x 40 cm
MR 1196

Innocent XII Pignatelli (Spinazzola, Bari 1615-Rome 1700), elected pope in 1691, carried out important reforms in the administration by abolishing numerous privileges and titles which favoured nepotism.
The *terracotta* bust is identified as the model for the bas-relief of the pope's honorary monument, in Naples Cathedral, realised in 1696.

Room 3 - Histories
The papal court

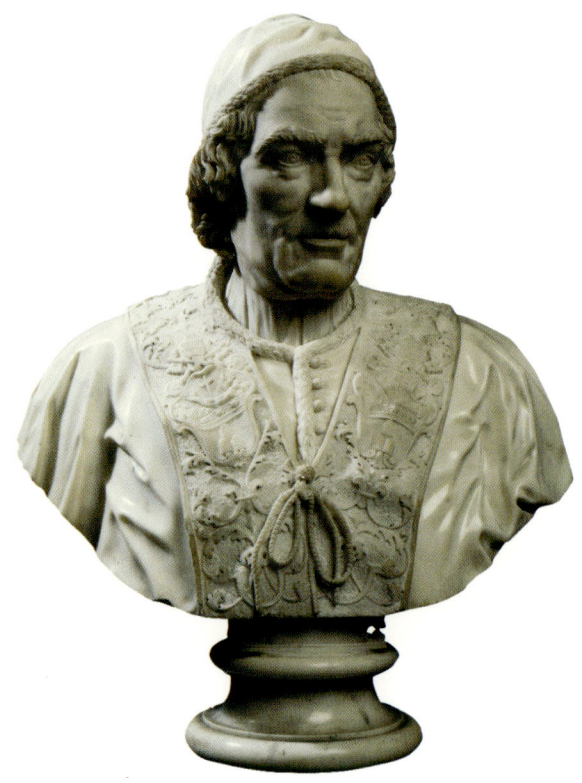

Christopher Hewetson (workshop replica)
Clement XIV Ganganelli, ca. 1773-1776
marble bust, 79 x 64 x 39 cm
MR 5702

The success, in the Anglo-Saxon world, of the bust of Clement XIV Ganganelli (Sant'Arcangelo di Romagna 1705 - Rome 1774), made by the Irish artist Christopher Hewetson, of which various autograph replicas are preserved in English collections, testifies to the overture of the Franciscan pope to the Protestant monarchy of the Hanover.

Room 4 - Histories
The papal court

In an overview of seventeenth-century Roman art, successful portrait artists included painters such as Ottavio Leoni, whose activity for the Roman nobility and clergy is recorded by his contemporaries, and Jacob Ferdinand Voet who, in Rome between 1663 and 1681, worked for the Colonna, for Christina of Sweden and for the Odescalchi, combining the attention to detail deriving from his Flemish artistic training, with the influence of the portrait-painting of Maratti and Gaulli.

A characteristic form of self-representation of the protagonists of the Roman court manifested itself through the public rituals of political and religious ceremonies. In the solemn processions of the cavalcades for the Possession of the pope after the election, of the feasts of *Corpus Domini* or of Minerva and on the infinite official occasions, the rigid social hierarchy organised sumptuous choreographies, in which the various personages of the curia or of the lay power were identified in the preordained and allusive sequence of the processions, by the styles and colours of their particular clothing and by their symbolic attributes.

Room 4 - Histories
The papal court

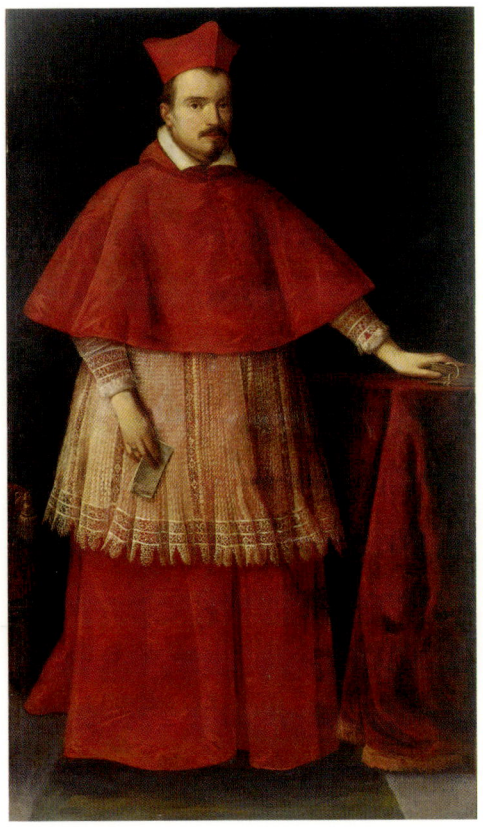

Ottavio Leoni
Portrait of cardinal Ludovico Ludovisi, ca. 1621
oil on canvas, 200 x 112 cm
MR 40930

This picture is part of the traditional current of portraits of cardinals and depicts Ludovico Ludovisi, created cardinal in February 1621, just a few days after the election to the papal throne of his uncle Alexander, under the name of Gregory XV. A collector and patron of the arts, he assembled a rich collection of pictures in the "Vigna di Porta Pinciana" (present-day Casino Ludovisi).

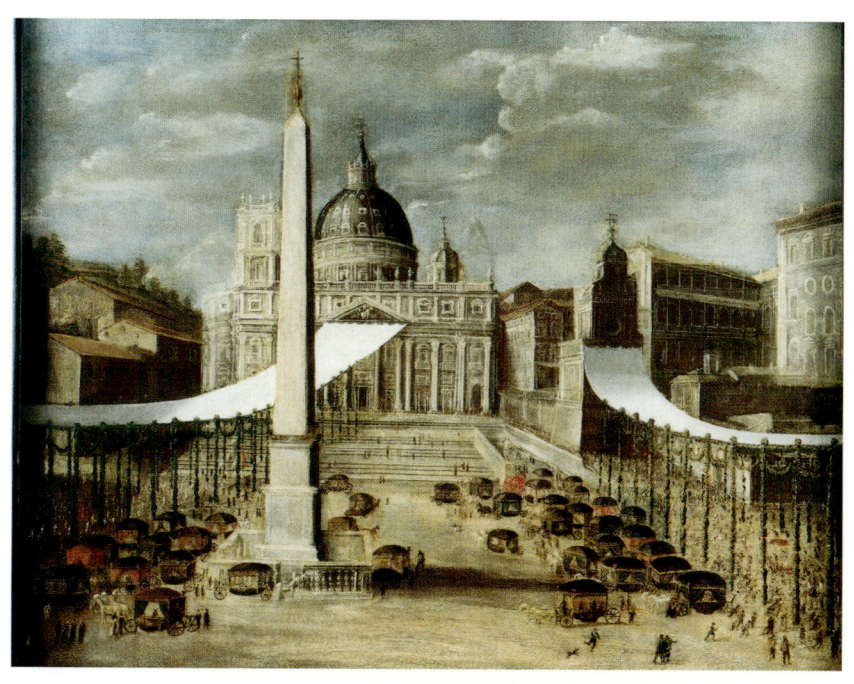

Unknown seventeenth-century painter
Corpus Domini procession in Saint Peter's Square at the time of Innocent X, ca. 1646
oil on canvas, 101.5 x 86.5 cm
Dep. PV 120

This painting depicts the procession for the feast of *Corpus Domini* in Saint Peter's Square, before the construction of Gian Lorenzo Bernini's colonnade. The presence of the bell-tower on the left-hand side of the façade of the basilica, which was demolished in 1646, suggests a date prior to this year.

Room 4 - Histories
The papal court

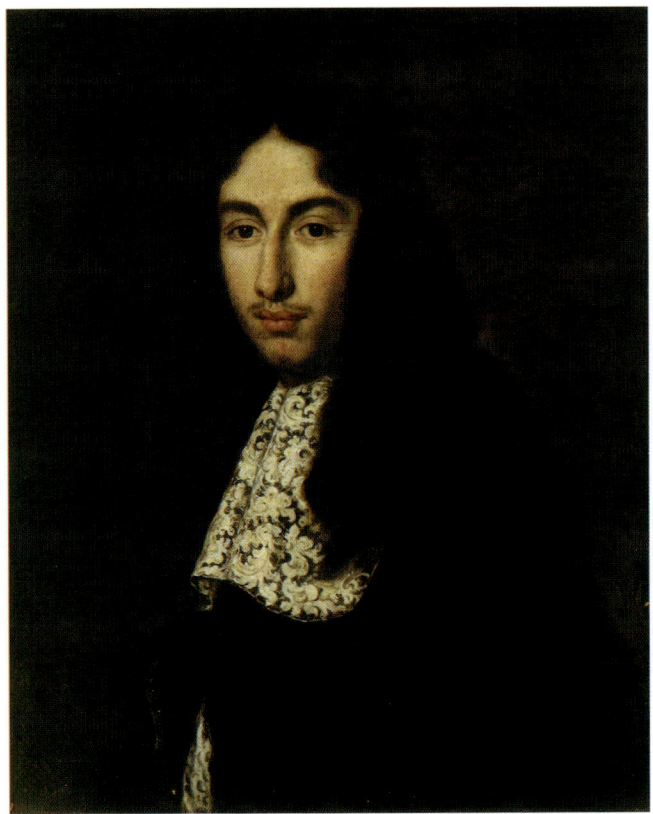

Jacob Ferdinand Voet
Portrait of Livio Odescalchi, 1676-1677
oil on canvas, 70 x 57 cm
MR 45716

Nephew of pope Innocent XI, Livio Odescalchi (Como 1655-Rome 1713) succeeded in acquiring, in 1692, a large part of the collections of Christina of Sweden. It is believed that this portrait of him is a replica of the canvas in the Walters Art Gallery in Baltimore, datable between 1676 and 1677, and attributed to Jacob Ferdinand Voet, author of numerous portraits of personages of the nobility and the papal curia.

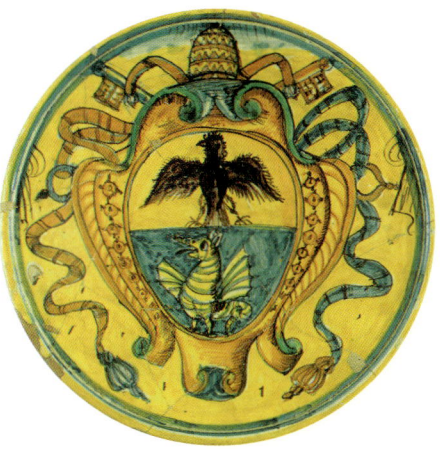 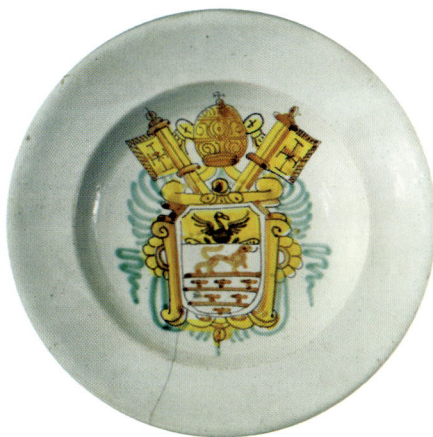

Made in Lazio
probably Castro or Acquapendente
Display plate
with papal coat of arms of Paul V Borghese,
1605-1621
ceramic, Ø 32 cm, Ø background 10 cm
MR 36888

In this display plate, decorated with the attributes of the Borghese family, the eagle and the dragon, the simplified lines of the drawing and the vibrant and balanced shades of colour foreshadow the mass production which would develop in the course of the century.

Made in Rome
Display plate
with the Odescalchi papal coat of arms
1676-1689
ceramic, Ø 34.5 cm, Ø background, 10.3 cm
MR 36887

In this large display plate the design of the Odescalchi coat of arms surmounted by the papal attributes, the keys and the tiara, is still linked to baroque forms.

37

Room 4 - Histories
The papal court

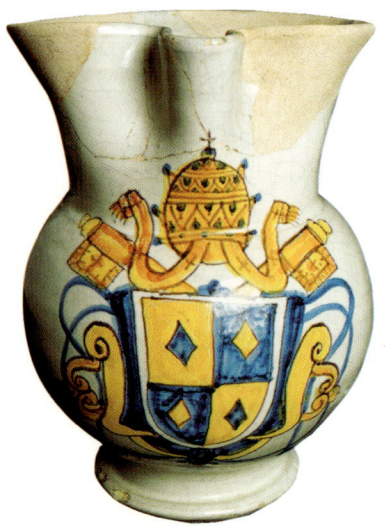

Made in Rome
*Jug with papal coat of arms
of Clement IX Rospigliosi,* 1667-1669
ceramic, Ø body 13.2 cm, height 17.8 cm
MR 36809

Made in Rome
*Jug with papal coat of arms
of Innocent XII Pignatelli,* 1691-1700
ceramic, Ø body 12.2 cm, height 17.3 cm
MR 35780

This small jug, with the Rospigliosi coat of arms in bright colours standing out on a thick milky layer, belongs to the so-called typology of "whites", a style in fashion, from the second half of the sixteenth century, prevalently for conventual or patrician dinner services.

This jug belongs to the great production of tableware with the Pignatelli insignia, perhaps alluding to the zeal of the reforming pope and to his charitable activities towards the poor and beggars.

Sala 5 - Histories
The papal court

The portraits by Giovan Battista Gaulli and Carlo Maratti reveal the influence of Berninian sculpture in terms of its skilful psychological rendering and capacity to express, with extreme naturalness, attitudes of nobility and authority.
In the eighteenth century, the influence of artists from the French court, mediated by the Academy of France, codified an official and courtly type of portraiture, characterised by spectacular backgrounds and sumptuous clothing, selected as the attributes of a ruling position. This resulted in the appearance of typologies of monumental portraits, against a background of draped stage wings or buildings opening onto views of the city, of which the double portrait of Benedict XIV with cardinal Silvio Valenti Gonzaga is an example.
A separate path, marked by the vibrant cultural climate of the court of Clement XI Albani, is revealed by the portraiture of Pier Leone Ghezzi who, through the use of caricature, is responsible for portraits of extraordinary characterisation and historical pictures which survive as an important testimony of society and costume.

Room 5 - Histories
The papal court

Giovan Battista Gaulli known as Baciccio (attributed)
Portrait of cardinal Giovan Francesco Ginetti, ca. 1681
oil on canvas, 85 x 73 cm
MR 1735

Datable to around 1681, the year Giovan Francesco Ginetti was elected cardinal, this painting revives various compositional schemes from the portrait-painting of Carlo Maratti, without, however, ruling out the influence of the portrait-busts by Gian Lorenzo Bernini.

Carlo Maratti (attributed)
Portrait of cardinal Giacomo Rospigliosi, ca. 1668-1669
oil on canvas, 98.5 x 75 cm
MR 45660

The portrait of Giacomo Rospigliosi (Siena 1628 - Rome 1684), created cardinal in December 1667, is a replica, probably an autograph one, of the portrait painted by Carlo Maratti. The success of the portrait which, with skilful psychological introspection expresses the dignity of the personage, was such that Clement IX himself, uncle of the cardinal, commissioned his own portrait from the artist.

Room 5 - Histories
The papal court

Pier Leone Ghezzi
Portrait of Clement XI, 1708 - 1712
oil on canvas, 127 x 78 cm
MR 38876

This portrait of Clement XI Albani (Urbino 1649 - Rome 1721), is considered to be one of the most significant proofs of the artist's portraiture, based on an intense physiognomic characterisation, with almost caricatural features, and a search for immediacy of gestures and expressions, accentuated by the rapid and frayed treatment of the pictorial matter.

Giovanni Paolo Panini
*Portrait of Benedict XIV with cardinal
Silvio Valenti Gonzaga*, ca. 1750-1759
oil on canvas, 131 x 178 cm
MR 5647

This double portrait of Benedict XIV Lambertini (Bologna 1675 - Rome 1758) with cardinal Silvio Valenti Gonzaga (Mantua 1690 - Viterbo 1756) is an emblematic image of the fellowship between the pope and his Secretary of State, who was responsible for the most important diplomatic agreements and the inspiration behind the exceptional cultural impulse of the pontificate.

Room 5 - Histories
The papal court

Pier Leone Ghezzi
Innocent X bestows the cardinal's hat on Fabio Chigi, 1724
oil on canvas, 275 x 425 cm
MR 45684

This painting of the investiture ceremony to cardinalship of the future pope Alexander VII, together with its pendant depicting *Clement XI bestowing the cardinal's hat on cardinal Giulio Alberoni,* testifies to the narrative and documentary vein of Pier Leone Ghezzi, combined with his interest in the portrait also in terms of its caricatural aspects, which has no bearing on the courtly tradition of the official portrait.

Room 6 - Histories
The Roman Senate

Having survived the fall of the Empire, the Roman Senate was reconstituted after the death of Innocent II, in 1144.
Reutilising the original name of Senatus Populusque Romanus, the institution, placed at the head of the recently founded Commune, combined legislative, administrative, judicial and financial powers. In the course of the thirteenth century, the original assembly structure was alternatively replaced by a magistracy of two senators or of just one, reflecting, in all probability, the equilibrium between the two factions of Guelphs and Ghibellines, or the prevalence of one over the other. After the years of the papacy's exile to Avignon and the popular political experience implemented by Cola di Rienzo, the Commune witnessed a remarkable reinforcement of its democratic component and, with the Statutes of 1360, a central role was awarded, in the government of the city, to the new magistracy of the three Conservators. The latter, appointed outside the baronial nobility, represented the entry into the city government of the so-called bourgeoisie of the arts and crafts. The function of the senator, no longer a Roman by statutory regulation, was restricted almost exclusively to a judicial context and assumed an essentially representative character. This structure of the Roman Senate, reaffirmed during the pontificate of Martin V (1417-1431), remained substantially in force until 1847 when Pius IX radically renovated the institution, creating, besides an executive Magistracy, consisting of the Senator and eight Conservators, a Council of one hundred members elected by the people. The entry of the Royal Army, on 20 September 1870, and the subsequent amalgamation of Rome into the Italian State, put an end to the existence of the Roman Senate.
Aware of representing the city, the heir to a secular transition, the Roman Magistracy adopted spectacular ceremonials and symbols, able to compete with those of the papal court. As well as regaining possession of the Campidoglio complex, as the traditional place of exercise of its administration, over the centuries the Senate decided on an official costume which from a sumptuous point of view restyled the typology of the Roman toga, enriching it with accessories derived from contemporary courtly clothing.

Roman sphere
Portrait of the senator Nicolò Bielke, ca. 1760-1765
oil on canvas, 206 x 147 cm
MR 16964

Publicly recanting Protestantism in Rome, in 1731, in symbolic continuity with the conversion of Christina of Sweden, count Nicolò Bielke (Stockholm 1706 - Rome 1765), played a central role in the anti-Lutheran propaganda of the Papal State. In 1737 he was elected senator of Rome, the greatest secular office of the city's government. In the background of the painting there is a view of the Piazza del Campidoglio.

Room 6 - Histories
The Roman Senate

Made in Rome
Senator of Rome's formal costume, 1865-1870
MR 45303

The senator's formal wear, with a silk toga or long robe interwoven with silver gilt, documents the clothing of the final years of the Capitoline magistracy. The accessories which complete the outfit, cuffs, pleated collar and sash, belonged to the marquis Francesco Cavalletti, the last senator of Rome, from 1865 to 1870.

Made in Rome
Roman senator's page's costume, ca. 1847-1870
MR 6121

The dress of the pages who accompanied the senator in all public ceremonies, consists of a waistcoat, culottes and a padded jacket, shaped on the front with false sleeves which hang from the armhole. The colours gold-yellow and amaranth-red which, in inverted ratios, also characterised the formal dress of the senators, recall those of the gonfalon of the Commune of Rome.

Room 6 - Places
The city of the Grand Tour

The works on display in this section of the exhibition – engravings and watercolours executed between the end of the eighteenth century and the mid nineteenth century – are testimonies of the journey to Rome made by foreign painters and of the flourishing market which arose to satisfy the demand of tourists and travellers who wished to take away with them a souvenir of the city and its environs.

As is known, in fact, the custom of the *Grand Tour* of Italy for young men from well-to-do European families was particularly in vogue in the years at the close of the eighteenth century and was considered to be an essential experience in the education of any cultured young man of the time.
A compulsory stop on this journey was, of course, Rome, where foreigners came face to face with the solemn ruins of the ancient

world, often covered with elements of vegetation that increased their "picturesque" and vaguely terrifying aspect, which proved to be so fascinating, or the sublime majesty of the environs where mountains covered with ruins and brushwood and splendid views of mysterious valleys unfolded before the gaze of the astonished visitors. This gave rise to the landscape painting of the travelling painters who trod the beaten tracks of the *Grand Tour* with their notebook, inseparable portfolio and folding stool; these were the sheets which, at the end of the trip, would provide an essential souvenir: this explains the enormous production of paintings, watercolours and engravings which artists, predominantly foreign artists, intended for the Grand Tourist market.

A selection of temperas and watercolours by Antoine-Jean-Baptiste Thomas is also on display: these are preparatory drawings for the illustrations of a book by Thomas himself, published in Paris for the first time in 1823 and subsequently in 1830. The small sheets draw inspiration from scenes of Roman life connected with religious festivals or with various anniversaries and are characterised by a vivacious and immediate stroke.

Dating to some years later is the group of works executed by John Ruskin, or attributed to him, a testimony to the periods of time which the English painter and critic spent in Rome; however, this man of culture who was particularly fond of the Middle Ages and the Pre-Raphaelites was not at all impressed by Rome and referred to it as "a horrible, dirty hole of the lowest order". And yet his *View of Santa Maria del Pianto* is of great efficacy, of which are exhibited the preparatory drawing, the lithograph taken from this and the small sheets which must have been part of a notebook and which depict the Via del Corso, the ruins of the palace of the Caesars, a view of Villa Borghese and the tomb of Rosa Bathurst in the Protestant cemetery: this sepulchre was built to honour the memory of the young Englishwoman who drowned in the Tiber in 1824 whilst riding along the riverbank.

Almost all the works exhibited here originate from the collection of baron Basile de Lemmermann and became part of the Museum's collections thanks to various acquisitions and donations which took place respectively in 1930, in 1955, in 1961 and finally in 1964. This gentleman of Russian origin had come to Rome in the second decade of the twentieth century as a diplomatic courier in the Tsar's embassy at the Quirinal and had put together a remarkable art collection, converting his house in Via Giulia into a small museum. It consists mainly of paintings and watercolours with a Roman subject by foreign artists, almost all of which were acquired abroad.

Room 6 - Places
The city of the Grand Tour

Abraham-Louis-Rodolphe Ducros (inv.), **Giovanni Volpato** (eng.)
General view of the Campo Vaccino, ca. 1778-1780
watercoloured etching, 523 x 752 mm
MR 6460

A magnificent image of the Roman Forum, the centre of political and economic life of the Republic and of the Empire, known as Campo Vaccino in the long period of decline which only terminated with the excavation campaigns in the nineteenth century that would upgrade it to Forum.
The Swiss painter Ducros was often in Italy and stayed in Rome, visited Naples and Sicily and worked for many years in collaboration with Volpato.

Abraham-Louis-Rodolphe Ducros (inv.) Giovanni Volpato (eng.)
Temple of Fortuna Virilis, ca. 1780
watercoloured etching, 360 x 514 mm
MR 195

We are in the Forum Boarium between the Palatine, Aventine, Campidoglio and Tiber: it was here that the ancient commercial port of the Romans once lay. The Temple of Fortuna Virilis seems to have been dedicated in antiquity to Portunus, god of the river port; the building was reorganised on several occasions until it was converted in the ninth century into a church consecrated to Santa Maria Egiziaca.

Room 6 - Places
The city of the Grand Tour

Abraham-Louis-Rodolphe Ducros (inv.) Giovanni Volpato (eng.)
Temple of Minerva Medica, ca. 1780
watercoloured etching, 523 x 752 mm
MR 6467

The Nymphaeum in the Licinian Gardens, better known as the Temple of Minerva Medica, took its name from a statue of Minerva with the serpent, the ancient symbol of medicine, which was found here.
The building, datable to the fourth century, had a decagonal plan with nine niches and two exhedrae but now shows only the brick nucleus without any marble facing.

Italian sphere
View of Rome from Villa Ludovisi, late eighteenth – early nineteenth century
tempera, 584 x 1030 mm
MR 4200

This is a "real" view of the city taken from Villa Ludovisi: it is possible to recognise from the left the churches of Santa Susanna and San Bernardo alle Terme, the cupolas and the bell-tower of Santa Maria Maggiore, in the background the Lateran Palace and on the right the Quirinal. In the foreground the garden of the villa which has not existed since the time of the parcelling-out decided on by the Ludovisi princes at the end of the nineteenth century.

Room 6 - Places
The city of the Grand Tour

John Goldicutt (inv.) **Robert Havell and son** (eng.)
Basilica of Maxentius or Temple of Peace, 1819
aquatint, 587 x 465 mm
MR 1620

The London architect and painter of buildings John Goldicutt made a tour of Italy between 1817 and 1818 and visited the typical destinations of the *Grand Tour*: Rome, Naples and Sicily. This engraving, drawn from his souvenirs of this trip, shows one of the most evocative sites in imperial Rome, the Basilica of Maxentius, known until 1780 by the name Temple of Peace.

Aleksei Petrovic Bogoljubov
View of the Tiber and Saint Peter's, 1854-1860
graphite and watercolour, 227 x 308 mm
MR 540

This watercolour can be dated to the period between 1854 and 1860, the years when the Russian painter was awarded a scholarship by the Academy of St. Petersburg, thanks to which he spent a period in Paris and in Düsseldorf and also went to Italy and to Turkey. Bogoljubov was a painter, draughtsman, watercolourist and lithographer and essentially produced historical pictures.

Room 6 - Places
The city of the Grand Tour

Abraham-Louis-Ducros (inv.), **Raffaello Morghen** (eng.)
View of the Ariccia valley, ca. 1784
watercoloured etching, 294 x 415 mm
MR 6322

Ariccia and its valley were places particularly dear to foreign artists and were compulsory stops on the way to Lake Albano and Lake Nemi. In the engraving, in the background, it is possible to recognise the church of Santa Maria Assunta by Bernini, whilst in the foreground the painter has depicted himself in the act of painting. The collaboration between Morghen and Ducros dates back to the years 1784-1786, a factor which allows us to date this work.

Hubert (inv.), **J.Merigot** (eng.)
Villa of Maecenas in Tivoli with figures playing music and dancing in the foreground, 1797
aquatint, 685 x 534 mm
MR 6254

Another place par excellence among those depicted as symbols of Rome and its environs, the Villa of Maecenas displayed itself to travellers on the *Grand Tour* as a repertoire of all that was fascinating and horrifying at the same time, from the wild vegetation growing on the ruins, to the sense of the picturesque which it evoked as a whole. The Temple of Hercules, until the end of the eighteenth century still known as the Villa of Maecenas, was correctly identified by the archaeologist Antonio Nibby.

Room 6 - Places
The city of the Grand Tour

John Ruskin
Piazza Santa Maria del Pianto, ca. 1840
graphite and watercolour, 340 x 460 mm
MR 706

This drawing, from which a lithograph would subsequently have been taken, can be dated to the 1840s and probably goes back to one of Ruskin's first stays in Rome. The English painter and critic, as is known, visited Italy several times, but was not the slightest bit charmed by the city which he found dirty and in a state of neglect.

Antoine-Jean-Baptiste Thomas
View of Rome by night with fireworks, ca. 1817
tempera, 217 x 297 mm
MR 14954

Antoine-Jean-Baptiste Thomas
Vendors of fried food for the feast of Saint Joseph, ca. 1817
watercolour and tempera, 223 x 298 mm
MR 14974

Rooms 8 - Places
Urban settings

In the seventeenth century, through the vision of baroque architecture, the city was conceived of as a continuum between isolated buildings and the surrounding space. It was precisely within this unified fabric, in the seventeenth and eighteenth century, that historical and cultural European events were represented as genuine theatrical actions.
Besides the Vatican complex, with the great Basilica square and the stage wings of the colonnade designed by Gian

Lorenzo Bernini or the Belvedere courtyard, in the Vatican palaces, the proscenium for the performances put on for prestigious guests, other places in the city, on account of their strategic position and their particular architectural layout, became ideal backdrops for the amplification of political and religious messages.

Piazza del Popolo, as well as the Gate of the same name, the main entrance to the Holy City which visitors from the North reached along the Via Flaminia, was the venue for processions of foreign sovereigns, ambassadors and prelates and led them, through the three streets in the form of a trident, to the heart of the city, evoking the universalism of the Holy See and the cosmopolitan character of its capital.

Equally emblematic of the rites of the papal court, the Piazza del Quirinale, with the palace of the same name which since 1592 had replaced the Vatican as the pope's residence, offered its ample vista to the multiform and colourful processions of personages visiting Rome.

Piazza Navona, enclosed inside the uninterrupted surface of the palazzos surrounding it, provided a secluded space, an open air theatre intended for sumptuous carousels and tournaments for more than two hundred years.

Rooms 8 - Places
Urban settings

Roman school
Tournament in the Belvedere courtyard,
first decade of the seventeenth century
oil on canvas, 155 x 284 cm
MR 1930

This was one of the last great chivalric tournaments and it took place on 5 March 1565 to solemnise the marriage of Annibale Altemps to Ortensia, half-sister of Charles Borromeo, both related to pope Pius IV. The canvas, realised much later, re-elaborates previous graphic images and shows the Belvedere courtyard in the Vatican after it was renovated by Pirro Ligorio.

Unknown painter
A visit by Innocent X to the fountain of the Four Rivers, 1651
oil on canvas, 285 x 187 cm
MR 35459

This painting, originating from the heirs of Gian Lorenzo Bernini, records a visit made by pope Innocent X to the Fountain of the Rivers in Piazza Navona which he commissioned from the famous artist. The sources record that the visit had been prepared before the official inauguration of the monument in order to surprise the pope with the sudden and evocative roar of the waters of the fountain.

Rooms 8 - Places
Urban settings

Unknown painter
Arrival at the Quirinal of the ambassador Nicolò Duodo, post 1714
oil on canvas, 149 x 486 cm
MR 1444

Unknown painter
Entry into Rome from Porta del Popolo
of the ambassador Nicolò Duodo, post 1714
oil on canvas, 149 x 486 cm
MR 1443

Nicolò Duodo, ambassador of the Most Serene Venetian Republic, solemnly entered Rome from Porta del Popolo on 12 August 1714 and on 30 September was received at the Quirinal by Clement XI. The two paintings show an ample view of the areas which the process passed and a lively representation of the procession and the crowd following its route, characterised by a lenticular description of the various styles of dress.

Rooms 8 - Places
Urban settings

Roman sphere
Cabinet with eighteen views of Rome,
last quarter of the seventeenth century
carved and gilded wood, bronze and painted parchment
75 x 118 x 31.2 cm
Dep. PV 121

This small cabinet with compartments, known as a "studiolo", reproposes the façade of a building with a crowning balustrade. It is decorated with eighteen views of Rome and religious ceremonies painted on parchment, which are inspired by a scheme recurrent in the illustrations of the seventeenth-century guides to the city.

Willelm II Van Nieulandt
View of Piazza del Popolo,
first quarter of the seventeenth century
oil on panel, 49.5 x 66 cm
MR 1200

The Flemish artist represents, with fidelity and attention to landscape detail, the corner of the square towards the basilica of Santa Maria del Popolo, as it appeared in the early seventeenth century, with the Flaminian obelisk commissioned by Sixtus V from the architect Domenico Fontana in 1589. A very close-up foreground and a wide low horizon characterise the composition.

Rooms 8 - Places
Urban settings

Viviano Codazzi
Caprice with Arch of Titus,
second – third quarter of the seventeenth century
oil on canvas, 94 x 124 cm
MR 1915

The painter depicts the north side of the arch incorporated into the mediaeval Frangipane fortresses: on the right are the walls of the Farnesian Gardens, on the left part of the colonnade of the temple of Antoninus and Faustina. The light-shade contrast and the strict perspective give this work a fixedness which renders the spatial representation homogeneous, solid and objective.

Room 9 - Places
Landscape

Considered to be a minor genre compared to religious and historical painting, landscape painting began to become established in the first half of the seventeenth century, with the presence, in Rome, of Flemish and Dutch artists whose works, although partly the result of a transposition between reality and imagination, are at the origin of modern landscape painting. In a constant osmosis between engraving and painting, depictions of the city's monumental sites multiplied in landscapes which were increasingly precise in terms of topography, accentuating attention in each example to the ancient ruin or to the monuments of Christianity, in line with the demand of growing tourism. Eighteenth-Century landscape painting, of which Gaspar van Wittel can be said to be the precursor with his search for perspective verisimilitude and his attention to the everyday routine of city life, gave way at the end of the century, to an emotional and intimist perception of landscape, which would culminate in the Romantic culture of the first half of the nineteenth century. In the second half of the nineteenth century, the growing art of photography would have a profound influence on landscape painting. Despite the fact that from 1850 onwards there was sharp controversy between photographers and artists, who felt themselves threatened by the representative fidelity of the new technique, the variety of possible shots suggested by the lens and the repertoire of live images which it could record and offer as a model constituted a compulsory reference for landscape painters. In Ippolito Caffi's paintings, the symbolic monuments of the city reveal a direct suggestion from photography, reflecting, in the expanded and transfigured views, an optical perception characteristic of this technique.

Room 9 - Places
Landscape

Paolo Monaldi and Paolo Anesi
Campidoglio and Campo Vaccino, second half of the eighteenth century
oil on canvas, 74 x 99.5 cm
MR 4041

This painting stems from the collaboration between Paolo Monaldi, author of the figures, and Paolo Anesi, author of the landscape: the former offers us a clear and idyllic view of daily and country life, the latter finds a compromise between the ideal landscape and the real view. It is interesting to be able to verify what the area of the Roman Forum looked like in those days.

John Newbolt
View of Rome from Villa Malta, 1834
oil on canvas, 64 x 85 cm
MR7060

The villa, the Roman residence of Ludwig of Bavaria and a meeting place for artists and intellectuals, stood on the highest point of the Pincio, from where it was possible to enjoy one of the views most admired by travellers, tourists and men of letters, also described by Goethe. The compositional clarity and the clear pale light relate the painting to contemporary works by German and Danish painters.

Room 9 - Places
Landscape

Ippolito Caffi
The Roman Forum, 1841
oil on paper applied onto canvas, 29 x 45 cm
MR5681

It depicts the remains of the Roman Forum brought back to light in the first half of the nineteenth century: the temples of Vespasian and Saturn, the arch of Septimus Severus, the Curia and the three partially buried columns of the temple of the Dioscuri. The trees on the right date back to the elm grove planted in the sixteenth century to shade the cattle market which was held here until the excavations began.

Ippolito Caffi
The Coliseum, ca. 1843-1847
oil on canvas, 35 x 58 cm
MR 217

Symbol of the greatness of ancient Rome and a compulsory stop for tourists and travellers, the Coliseum is depicted here with great attention to realistic detail, which makes it surprisingly similar to several of the first nineteenth-century photographs with which it shares a standardisation of the image. The painting shows the remains of the conical fountain known as "Meta Sudante", now demolished.

Room 9 - Places
Landscape

Ippolito Caffi
The Coliseum seen from above, 1855
oil on paper applied onto canvas, 56 x 90 cm
MR 5679

The Flavian amphitheatre is depicted in an unusual way from above the arches on the top floor, making it possible for the eye to sweep over a wide panorama from Santo Stefano Rotondo, by way of the Caelian hill and the pyramid of Gaius Cestius, as far as the Palatine.
The area is permeated by a warm natural luminosity, the result of the palette which has been used.

Room 9 - Places
Landscape

Ippolito Caffi
Fog over Rome, 1847
oil on paper applied onto canvas, 17 x 28 cm
MR 5687

This unusual view of Rome from the Pincio, shrouded in morning fog in which it is just possible to make out the cupolas of San Carlo al Corso and of Saint Peter's, shows how in the mid nineteenth century the concern with description was replaced by a decidedly modern attention to atmospheric phenomena.

Michel Angelo Pacetti
Review of the French troops in Saint Peter's Square, 1855
oil on canvas, 97 x 134 cm
MR 175

This work, sent to Paris to the International Exhibition of 1856, depicts a parade of French troops in Saint Peter's Square with the insignia of the eagles, symbol of loyalty to the papal government, and is presented from a lateral point of view which expands the space making it possible for the author to enucleate a certain number of standardised figures.

Room 10 - Culture
Artists in the capital

Starting in the sixteenth century, the slow process of emancipation of artists from their role as artisans and the recognition of the figurative arts as *artes liberales*, rather than mechanical and manual arts, went hand in hand, throughout Europe, with their release from the Corporations and the establishment of the Academies. In the eighteenth century Rome represented a culminating moment in this evolution.

The ancient tradition and prestige of public institutions such as the Academy of Saint Luke, founded in Rome in 1577, which was joined in 1754 by the Academy of the Nude in Campidoglio, the strong influence of the Academy of France and the importance of the academies held in studios of international repute such as that of Anton Raphael Mengs, amplified and codified the requisites of the profession, justifying the social elevation of the artist.

On the other hand, the tourist traffic in the papal city, the symbolic place of the origins of western culture and a compulsory destination not only for the study of the figurative arts, but also for the completion in the education of the entire European ruling class of the time, fed the artistic market

with renewed intensity, allowed for increased earnings and gradually emancipated painters, sculptors, engravers and goldsmiths from their noble and papal commissioners.

The Arcadian Academy which, founded in Rome at the end of the seventeenth century on the model of the intellectual circle of Christina of Sweden, was the greatest literary institution and guided every aspect of Roman cultural life, welcoming and electing as Arcadians many of the artists working in the city.

The portraits of illustrious Arcadians, collected from the mid eighteenth century, were often painted and donated by artists who were members of the institution.

The dignity and nobility of the artist and his profession emerges in the portraits of the artists of the eighteenth century, isolated or in a group, and in those of their families, expressing a precise social awareness and heralding a future of economic independence and ideal freedom which the next century, albeit with the contradictions of the market and of bourgeois society, would gradually make possible.

Room 10 - Culture
Artists in the capital

Giuseppe Bartolomeo Chiari
Self-portrait with his family, ca. 1709
oil on canvas, 116 x 90 cm
MR 41383

This self-portrait with his family by Giuseppe Chiari, one of the most active and admired artists during the pontificate of Clement XI, represents a private celebration of harmonious sentimental ties and of social success, hinted at in the affectionate correspondence of gestures and expressions of the various figures and in the ostentation of refined lace and jewels in the clothing of the wife and children.

Giuseppe Bottani
*Portrait of Caterina Valadier
with her children Giuseppe and Maria Clementina*, ca. 1766
oil on canvas, 72 x 60 cm
MR 1011

This portrait represents Caterina Della Valle, daughter of the sculptor Filippo and wife of the famous goldsmith and caster Luigi Valadier. The allegorical character of the portrait, which alludes to the myth of Leto with her children Diana and Apollo, and the classical harmony which pervades it, make the painting a proof of the prestige achieved by artists in Rome in the eighteenth century.

Room 10 - Culture
Artists in the capital

Stefano Tofanelli
Self-portrait with Bernardino Nocchi, his father Andrea and brother Agostino, 1783
oil on canvas, 112 x 87 cm
MR 3554

Painted in 1783 for his patron Paolo Santini from Lucca, this self-portrait with his teacher and friend Bernardino Nocchi, his father Andrea and brother Agostino, who would soon follow in Stefano's footsteps, represents a sort of intimate and private record of family affections and professional relations.

Teresa Tibaldi (copy after Pompeo Batoni)
Portrait of Giacinta Orsini, in Arcadia Euridice Aiacidense,
1757-1758
oil on canvas, 136 x 99 cm
Dep.Arc. 5

This painting celebrates Giacinta Orsini, an Arcadian poetess, who died in childbirth at only nineteen years of age. The portrait depicts the typical elements of the iconography of Arcadia, from the lyre, to the laurel wreath, to the myth of the Hippocrene fountain in the background, whilst the head of Minerva and the armillary sphere allude to Giacinta's great love of science.

Room 10 - Culture
Artists in the capital

Christopher Hewetson
Bust of Maria Maddalena Morelli Fernandez,
in Arcadia Corilla Olimpica, 1776
marble, 65 x 39 cm
Dep. Arc. 173

The bust of Maria Maddalena Morelli, a highly successful improvising poetess, was made and donated to the Arcadian Academy by Christopher Hewetson, to celebrate the coronation of Corilla in Campidoglio, in 1776.

Christopher Hewetson
Bust of Luigi Gonzaga di Castiglione,
in Arcadia Emireno Alantino, 1776
marble, 65 x 40 cm
Dep. Arc. 172

Luigi Gonzaga, a nobleman without means, with progressive literary and philosophical leanings, companion and supporter of the poetess Maria Maddalena Morelli, commissioned his bust from the Irish sculptor Hewetson so that it might be placed next to that of the poetess in the Arcadian Academy collection.

Room 10 - Culture
Artists in the capital

Pietro Labruzzi
Portrait of Giovanni Battista Piranesi, 1779
oil on canvas, 71 x 58 cm
MR 3440

This painting was probably commissioned by his son Francesco. The sheet of paper in the artist's left hand with the ruins at Paestum, the last work the engraver realised in collaboration with his son, and the candelabrum, depicted in the background, with the allegorical reliefs alluding to the various seasons of the age of man, make the painting a complete expression of filial gratitude and of serene meditation on human existence.

Antonio Canova
Self-portrait, ca.1799
oil on canvas, 91 x 74 cm
MR 1410

This painting, in which it is possible to glimpse in the background the relief with The death of Adonis, modelled in 1797, could be ascribed to 1799, the year in which the *Self-portrait as a sculptor* (dated and signed) was painted. In the latter, housed in the Possagno Gallery of plaster casts, it is possible to detect formal analogies with the portrait in the Museum of Rome and the same realistic notations of the physiognomy and the signs of age.

Room 10 - Culture
Artists in the capital

Pompeo Girolamo Batoni
Portrait of John Staples, 1773
oil on canvas, 264 x 198 cm
MR 1974

The portrait of John Staples is an emblematic work of the portraiture of Pompeo Batoni who, by reworking the characteristics of Van Dyck's courtly portrait, fully expresses the tastes of the growing clientele of travellers, English travellers in particular, who wished to fix and celebrate the memory of their stay in Rome.

Room 11 - Culture
Microcosm of the beautiful

The portraits which Pompeo Batoni paints of people on a visit to the capital in the second half of the eighteenth century, define a veritable icon of the so-called Grand Tourist, the protagonist of the journey of initiation to Italy and in particular to Rome, capital of the classical world.

Besides the demand for the souvenir portrait, the extraordinary flow of tourists in the capital, fed the traffic in excavations, restorations and sales of antique finds and an artistic output inspired by the classical world, which gradually became increasingly technically variegated and mass-produced.

Together with the etchings of views or the reproductions of antique finds by the very famous Giovanni Battista Piranesi and his son Francesco, travellers could buy refined miniaturised reproductions of famous statues, made of bronze in the workshops of goldsmiths and casters such as Luigi Valadier or in *biscuit* [unglazed pottery], in the factory set up in Rome by Giovanni Volpato in the 1780s. Sumptuous furnishings made of marble and precious metals were produced in the workshop of Francesco and Luigi Righetti, whilst refined cabinet makers reproduced in marquetry the decorations found in early painting, popularised by engraved reproductions.

A lavish artisan glyptic industry flourished in the capital, reproducing antique cameos. The repertoire of these models available in the workshops of engravers of semi-precious stones was publicised through the diffusion of white plaster casts which, backed with velvet and framed, were sold and admired as furnishing elements.

Room 11 - Culture
Microcosm of the beautiful

Giovanni Volpato
Melpomene
biscuit, 26.5 x 14.5 cm
MR 16960

This small statute reproduces one of the Tiburtine or Vatican Muses, found in 1774 in an excavation of the Villa of Cassius at Tivoli. Acquired for the Pio Clementino Museum, the group of Muses was placed in a room frescoed by Tommaso Conca with mythological and historical themes inspired by the arts.

Giovanni Volpato
Faun
biscuit, 29.5 x 10.8 cm
MR 16959

This small statue is inspired by a statue group known as Invitation to the dance, of which an example was preserved in the Giustiniani Collection.

Room 11 - Culture
Microcosm of the beautiful

Bartolomeo Pinelli
Achilles drags the body of Hector, 1833
terracotta, 50 x 90 x 40 cm
Dep. PV 141

This *terracotta* is inspired by the tragic episode in the Iliad which tells how the body of Hector, killed in a duel, was dragged behind Achilles' chariot. Between the late eighteenth century and the early decades of the nineteenth century, the theme attracted many artists, who shared in an interpretation of classical antiquity as an expression of violent and ancestral passions.

Room 11 - Culture
Microcosm of the beautiful

Neapolitan school
Portrait of Luigi Righetti, second quarter of the nineteenth century
oil on canvas, 95 x 62 cm
MR 5829

The activity of Luigi Righetti is closely interwoven with that of his father Francesco, together with whom, replacing Giuseppe Valadier in 1805 in the direction of the *Fonderia Camerale* and of the *Fabbrica di San Pietro*, he contributed to a vast production of refined furnishing objects made of precious marbles and metals.

Unknown painter
Portrait of Paola Righetti of the Carrozzi-Lecce marquises
second quarter of the nineteenth century
oil on canvas, 75 x 62 cm
MR 5830

This painting depicts Paola Carrozzi-Lecce, wife of Luigi Righetti, wearing a set of jewels consisting of about forty cameos; two of them reproduce two statues by Canova: the *Dancer with her hands on her hips* (Saint Petersburg, Hermitage) and the *Dancer with her hand on her chin* (Rome, Palazzo Corsini), datable between 1806 and 1810.

Room 11 - Culture
Microcosm of the beautiful

Francesco Podesti
Portrait of the engraver Pietro Girometti, ca. 1831
oil on canvas, 98.5 x 74 cm
MR 179

The personage depicted is Pietro Girometti, a medallist and engraver, active in Rome in the first half of the nineteenth century and son of the most famous Giuseppe, *Incisore Camerale* to the papal mint, whose *studio* in Via del Corso was known and frequented by foreign travellers and by the cosmopolitan society of the time.

Giuseppe Girometti
Ptolemy II and Arsinoe
red-brown wax on slate, Ø 13.2 cm
MR 5982

Giuseppe Girometti
Ptolemy II and Arsinoe
plaster, partially gilded, 14.8 x 12.5 cm
MR 13535

The wax model and the cast are related to a cameo, engraved in an oriental sardonyx, a copy of the famous so-called Gonzaga Cameo.
The original belonged to the dukes of Mantua, to Christina of Sweden and, subsequently, to Pius VI; it was taken to France in 1798, together with much of the pope's collection. Since 1814 at Saint Petersbourg.

Room 11 - Culture
Microcosm of the beautiful

Pietro Girometti
Achilles
plaster, 8.2 x 7 cm
MR 13533

Cast of a version of the arabian agate cameo with the same subject, preserved at the Musée des Arts Décoratifs in Paris. The head of Achilles is inspired by an ancient marble bust in the Schuvaloff collection, now preserved in Saint Petersburg, whose iconography had enjoyed a certain fortune in the eighteenth century.

Benedetto Pistrucci
Nuptials of Cupid and Psyche
white wax on slate, Ø 8 cm
MR 36468

This is a reproduction of the famous "Marlborough cameo", in a two layers onyx, signed by an engraver of the first century b.C. and currently housed in the Museum of Fine Arts in Boston. The subject was used several times in the repertoire of eighteenth-century wall decorations.

Elena or Maria Elisa Pistrucci
Ideal head
white wax on slate, Ø 5 cm
MR 36484

Maria Elisa Pistrucci
Minerva
white wax on slate, Ø 7.5 cm
MR 36478

The female profile for a cameo of the model is inspired by the representations of Hera which appear on the coins of the fourth century b.C. from Elis.

This model for a cameo reproduces a small bronze, housed at the time in the collection of Richard Payne Knight and now in the British Museum in London.

Room 12 – Culture
The fashion code

The eighteenth century is the century which led to the modern concept of fashion, based on sudden changes in taste. It was characterised by the uniformity with which styles were manifested throughout Europe. The political and economic supremacy of the French court dictated the rules of dress for almost the entire century. Only in the second half of the eighteenth century did English styles become successfully established, inspired by a greater rationality and sobriety of costume.

The most representative female garment of the century, used in France and in Italy, was the *Robe à la française*, also known as an *andrienne*, because it was worn, in 1703, at the *Comédie Française* for the representation of the *Girl from Andros* by Terence. Initially a source of scandal, on account of its excessively free forms compared to traditional styles, the *andrienne* became part of female clothing and in around the 40s the fashion was accepted at court. Its distinctive characteristics are the false posterior cape, which falls freely over the back, and the presence of side extensions, which were supported by panniers, substructures in materials such as rush or metal which could reach remarkable sizes. Under the influence of English fashion, this style, which remained in use as a formal dress, was joined by more informal models, characterised by a less expanded line on the hips, and without the cape and train.

The typical male costume maintained throughout the century its structure in three garments – tailcoat, waistcoat and

trousers to the knee, *or culottes* – deriving from the traditional *habit à la française*. Profound changes took place in the line, which was simplified, and in the decoration: the metallic yarn brocades were replaced with silks and velvets with polychrome embroidery, whose placing was limited, in the final years of the century, to facings, pocket flaps, collar and waistline.

Room 12 – Culture
The fashion code

Female formal dress (Robe à la française)
1760–1770
MR 9118

This dress, in pink silk *faille*, has preserved intact the distinctive characteristics of the *robe à la française*, with the wide side extensions, supported by panniers. Typical of the epoch is the precious brocade on a pink background, in metallic yarn and polychrome silk, and the double meander motif, created by lace motifs and shoots.

Female formal dress (Robe à la française)
1760-1770
MR 3522

This *robe à la française* made of blue shot taffeta with floral motifs and lace reflects the fashion which was established in the 50s and 60s of the century. In these decades the sinuous lines of the lace motifs from which emerge bunches of polychrome flowers, use light materials as a support. These include shot taffetas, which create different reflections with each movement the lady makes and lend themselves to being curled or bent, according to the dictates of the current fashion.

Room 12 – Culture
The fashion code

Man's formal waistcoat, ca. 1780
MR 7066

This man's waistcoat in silk *satin* of a coral red colour, embroidered with spangles, beads, bullion and moulded metallic laminettes and glass inserts, reflects, in the simplified line, the dictates of the eighth decade of the eighteenth century, although it preserves the shaping of the tails which tend to widen with a slightly receding movement below the waistline.

Man's formal tailcoat, 1790-1800
MR 7063

This tailcoat made of damask velvet on a black background, decorated with a tiny motif of vine leaves and tendrils in blue silk, is embroidered with floral motifs. Its style, with receding tails, medium-high stand-up collar and close-fitting sleeves, the typology of the silk and bullion embroidery, as well as the refined weaving technique, are features which suggest a date between the end of the eighteenth century and the start of the nineteenth.

ITINERARY – Second Floor

Room 1 - Great families
The Barberini

A family originally from Tuscany, in Rome since the sixteenth century, the Barberini reached the height of their power in 1623 with the election to the papal throne of Urban VIII (Florence 1568 – Rome 1644), whose real name was Maffeo Barberini. The splendour of the family was contributed to by the nepotism of the pope and the patronage of his nephews, the cardinals Antonio junior and Francesco senior, and of the prefect of Rome Taddeo Barberini. These were the years in which Gian Lorenzo Bernini completed, for Urban VIII, the family palace and realised the majestic bronze baldachin in St. Peter's basilica. The prestige of the Barberini was manifested through sumptuous ceremonies offered to eminent personalities visiting Rome. Memorable examples include the Joust of the Saracen, organised by cardinal Antonio in 1634, in honour of prince Alexander Charles of Poland and the carousel for queen Christina of Sweden, staged in the courtyard of the family palace in 1656. Printed chronicles

and paintings were commissioned from artists in the family *entourage*, including Andrea Sacchi, in order to ensure that the memory of these performances would survive. In the Barberini tapestry factory, set up in 1627 by cardinal Francesco senior, which was active until his death, in 1679, and entrusted to the direction of Pietro da Cortona, tapestries were woven showing *Scenes from the life of Constantine*, in completion of a series, dedicated to the same theme, which the cardinal had received as a gift from Louis XIII, during a diplomatic mission to France in 1625.

Room 1 - Great families
The Barberini

Agostino Tassi
Investiture of Taddeo Barberini as prefect of Rome in the Pauline Chapel, 1631-1633
oil on canvas, 175 x 443 cm
MR 5700

The nephew of Urban VIII was invested as Prefect of Rome on 5 August 1631. The pope is depicted in the act of handing to the newly elected prefect the attributes of his office. Tassi, as well as documenting the historical event, faithfully illustrates the appearance of the Pauline chapel about twenty years after it was built.

Andrea Sacchi, Filippo Gagliardi, Manciola
Joust of the Saracen in Piazza Navona on 25 February 1634
second quarter of the seventeenth century
oil on canvas, 300 x 220 cm
MR 5699

The *Joust of the Saracen* was staged in Piazza Navona for the visit of prince Alexander Charles of Poland during the 1634 Carnival. Commissioned by Cardinal Antonio Barberini, the festival revived the rules of the military and literary contest, of chivalric tradition, realising a theatrical spectacle with enormously evocative ephemeral displays and costumes.

Room 1 - Great families
The Barberini

Giovanni Ferri known as Giovanni Senese (attributed)
*Cavalcade of Urban VIII to Santa Maria sopra Minerva
on the occasion of the festival of Our Lady of the Annunciation*
fourth decade of the seventeenth century
oil on canvas, 59 x 172 cm
MR 8890

This painting, attributed to an artist specialising in celebrative works of lay and religious events, depicts the procession of the pope which each year went from the Vatican to the Church of Santa Maria della Minerva for the feast of the Annunciation. With the intention of recording the memory of the route, the image faithfully follows the models of contemporary engravings, citing, in an imaginary vista, the places that marked the most significant stages of the procession, from the Vatican Palaces to Piazza di Pasquino along Via Papalis.

Room 1 - Great families
The Barberini

Filippo Gagliardi and Filippo Lauri
*Carousels in the courtyard of Palazzo Barberini
in honour of Christina of Sweden on 28 February 1656*, ca. 1656
oil on canvas, 231 x 340 cm
MR 1656

The *Joust of the Carousels* staged in the courtyard of Palazzo Barberini, in honour of Christina of Sweden, in the 1656 Carnival, is one of the theatrical occasions emblematic of the taste for baroque festivals. The complexity of the stage machinery is recorded in the painting, which fixes the richness of the ephemeral displays and costumes and manages to recreate the effect of an illumination, which, as the chronicles of the time record, was brought about by means of extraordinary devices.

Pietro Berrettini known as Pietro da Cortona (attributed)
Jacob van den Vliete, known as Jacopo della Riviera (attributed)
Baldachin roof with the Barberini bees, 1633
tapestry woven in high heddle in wool and silk, 370 x 265 cm
MR 45591

This tapestry constituted the roof of the baldachin for the cardinal's throne intended for the hall of honour in Palazzo Barberini and was part of the complex of hangings with *Scenes from the life of Constantine* made, in the 1630s, in the tapestry factory founded in Rome by cardinal Francesco Barberini. The cartoons were realised by Pietro da Cortona, whilst the weaving was the work of the Fleming Jacopo van den Vliete, who directed the tapestry factory from 1627 to 1639.

Room 1 - Great families
The Barberini

Pietro Berrettini known as Pietro da Cortona (school)
Constantine knocks down the pagan idols, 1635-1636
oil on canvas, 96.4 x 79 cm
MR 5834

This sketch corresponds to one of the Barberini tapestries, dedicated to the *Stories of Constantine,* now housed in the Philadelphia Museum of Art and it would seem possible to ascribe it to a pupil of Cortona's who unquestionably involved his workshop in the realisation of the numerous models for the weaving of the hangings.

Roman sphere
Cabinet to second half of the eighteenth century
carved wood veneered with ebony with decorations in "commesso" [a sophisticated technique of creating inlays] using semi-precious stones and embossed, gilded metal,
49 x 64 x 28 cm
Dep. MC 121

This richly decorated cabinet, with the front divided into double drawers either side of a central niche with columels and a split gable, is a typology of furniture used, since the sixteenth century, to contain precious collections of tiny objects and referred to, in the seventeenth-century inventories, as a "studiolo".

Room 2 - Great families
The Barberini

The medals, originating from the Barberini collection and housed in the seventeenth-century medal cabinet, record the most important events of the pontificate of Urban VIII: the baldachin in Saint Peter's basilica (1633), restorations of the churches of San Caio, Sant'Anastasia and Santa Bibiana, the restoration of the Lateran Baptistery, the magnificent Barberini palace (1638) and the construction of the Villa di Castel Gandolfo, since that time the summer residence of the popes. One medal celebrates the first centenary of the Company of Jesus, testifying to the support of Urban VIII and cardinal Antonio for the Jesuits. Urban VIII's official engraver was Gaspare Mola, nicknamed the "Lombard Cellini". Medallist, sculptor and armourer, as well as an engraver of mint marks, he arrived in Rome in 1623, after many years spent in the service of the Gonzaga, Estensi and Medici families. On his death, in 1640, he was succeeded by his nephew Gaspare Morone Mola, active in the Mantua Mint and in Rome from 1637. In his capacity as engraver of the papal mint marks, he executed the last medals of the Barberini pontificate.

Gaspare Mola
Medal of Urban VIII
Baldachin of Saint Peter's in the Vatican and altar of the confession, 1633
bronze, 26.6 gr, Ø 41 mm
MR 6727

The medal was struck for the inauguration of the baldachin in Saint Peter's, whose realisation, commissioned by the pope from Gian Lorenzo Bernini in 1624, immediately after his election, was completed in 1633.

Gaspare Mola
Medal of Urban VIII
Façade of the church of S. Bibiana, 1634
bronze, 26.5 gr, Ø 40 mm
MR 6758

This church, dedicated to the martyr of the same name, was restored at the pope's behest on the occasion of the discovery of the relics of the Saint in 1624. Gian Lorenzo Bernini was commissioned to design the new façade, whilst Pietro da Cortona frescoed the central nave with Stories of Saint Bibiana.

Gaspare Mola
Medal of Urban III
Façade of the church of S. Anastasia, 1636
bronze, 20 gr, Ø 40 mm
MR 6680

The restoration of the church of Sant'Anastasia was part of the papal programme to renovate the oldest churches, linked to the memory of the early Christian martyrs. The design, with the façade which recalls late-Renaissance schemes, flanked by two bell-towers, is attributed to Luigi Arrigucci (1575-1654), Carlo Maderno's successor as direction of papal buildings.

Room 2 - Great families
The Barberini

Gaspare Mola
Medal of Urban VIII
Cross-section of the Lateran Baptistery, 1637
bronze, 28.4 gr. Ø 42 mm
MR 6662

Gian Lorenzo Bernini, in collaboration with the architect Domenico Castelli (1582-1657), carried out many works of restoration and embellishment, at the behest of Urban VIII, in the ancient Lateran Baptistery. For the lantern of the new cupola Andrea Sacchi painted eight canvases with *Stories from the life of the Baptist.*

Gaspare Mola
Medal of Urban VIII
View of Castel Gandolfo, 1637
bronze, 23.8 gr, Ø 41 mm
MR 6733

This medal celebrates the conversion of Villa di Castel Gandolfo into the Apostolic Palace, chosen by Urban VIII as a place for summer holidays. Designed by Carlo Maderno, with sober architecture and a boundary wall, the building was completed, between 1624 and 1629, by Bartolomeo Bracciolin and Domenico Castelli

Gaspare Mola
Medal of Urban VIII
Façade of the church of San Caio, 1639
bronze, 42.4 gr, Ø 41 mm
MR 6679

The rebuilding of the church of San Caio, who was martyred during the Diocletian persecutions, was part of the Counter-Reformation programme pursued by Urban VIII to salvage the memory and the monuments of early Christianity. The building, reconstructed in 1631 by two minor architects, still tied to the mannerist tradition, was demolished in 1878 in order to widen the ancient Via Pia in the stretch afterwards named Via XX Settembre.

Room 3 - Great families
The Barberini

The series of Barberini busts constitutes a gallery of the protagonists of the family's golden age, at the height of its prestige during the pontificate of Urban VIII, and represents a significant repertoire of the typology of the bust portrait in Rome at the height of the seventeenth century.
All originating from the Barberini collection, the portraits were for private use, but have a close typological relationship with the portraits depicted in other celebrative monuments of the various personages.

Despite a relative chronological distance and the different premises of artists such as Francesco Mochi, whose artistic background was Tuscan, and Lorenzo Ottoni or Bernardino Cametti, followers of Gian Lorenzo Bernini, all the busts show a similar dynamic collocation of the figure in the space, a refined naturalism in the decoration of the physical characteristics and a spontaneity of expression which reveals a great awareness of the hegemonic role.

Room 3 - Great families
The Barberini

Francesco Mochi
Bust of Carlo Barberini General of the Holy Roman Church,
ca. 1630
marble, 84 x 80 x 36 cm
MR 1097

Elder brother of pope Urban VIII and appointed by the latter as commander of the papal troops, he died in Bologna in 1630 whilst on a mission. The bust was documented in Palazzo Barberini from 1642. Francesco Mochi had already realised for the Barberini the sculptures in the family chapel in Sant'Andrea della Valle.

Lorenzo Ottoni (attributed)
Bust of cardinal Antonio Barberini junior, ca. 1680
marble, 73 x 67 x 32 cm
MR 1988

The subject portrayed is cardinal Antonio Barberini, the youngest of Urban VIII's nephews and the instigator of memorable festivals such as the *Joust of the Saracen* in Piazza Navona and of theatrical performances in the family palace, whose staging was overseen by Gian Lorenzo Bernini.

Room 3 - Great families
The Barberini

Lorenzo Ottoni (attributed)
Bust of cardinal Francesco Barberini senior, ca. 1680
marble, 70 x 60 x 30 cm
MR 1987

Cardinal Francesco Barberini, an important figure in the Roman curia at the time of Urban VIII, is remembered for his deep artistic, scientific and erudite interests, testimony of which remains in the rich library in his ownership, which was later merged with the Vatican collections.

Bernardino Cametti
Bust of Taddeo Barberini Prefect of Rome, 1704
terracotta, 95 x 65 x 30 cm
MR 1096

This terracotta bust is probably the model for the cenotaph in the church of Santa Rosalia in Palestrina, dedicated to Taddeo Barberini, nephew of Urban VIII and appointed prefect of Rome in 1631. His election to this honorary office, taken away from the Della Rovere family for the first time in centuries, was accompanied by spectacular processions and ceremonies, depicted in a series of paintings and recorded in contemporary chronicles.

Room 4 - Great families
The Rospigliosi

A cultured prelate, the author of theatrical works admired in the Barberini *entourage*, Giulio Rospigliosi was elected pope in 1667 under the name of Clement IX (1667-1669). His short pontificate sanctioned the establishment, on the Roman scene, of this rich family originally from Pistoia, allowing for the transfer to the capital of its members and its definitive political and social legitimisation.

The aim of true economic stability was achieved, in 1670, as a result of the marriage of Giovanni Battista Rospigliosi and Maria Camilla Pallavicini. Growing prestige was symbolised by the acquisition of the splendid Palace on the Quirinal in 1708 and the construction of the family chapel in San Francesco a Ripa, between 1710 and 1726, with the funeral monuments of Stefano and Lazzaro Pallavicini, of Maria Camilla and her husband Giovanni Battista Rospigliosi. The repertoire of images, now housed in the Museum of Rome as a result of the acquisition of the Rospigliosi collection, includes an unusual series of portraits of the same child, perhaps Pietro Banchieri, nephew of Giovanni Battista Rospigliosi, who moved with his parents to Rome in 1667.

Pierre Ronche (?)
Portrait of Pietro Banchieri as a dancer, 1667-1669
oil on canvas, 135 x 98 cm
MR 929

The series of fancy dress portraits of the young Pietro Banchieri, son of the pope's niece, Caterina Banchieri, testifies to the Rospigliosi family's taste for the theatre and dressing up, which must have been contributed to by the literary production of Cardinal Giulio, later Clement IX, and his habitual visiting of the circle of Christina of Sweden.

Room 4 - Great families
The Rospigliosi

Pierre Ronche (?)
Portrait of Pietro Banchieri as Cupid, 1667-1669
oil on canvas, 130 x 94 cm
MR 43751

Pierre Ronche (?)
Portrait of Pietro Banchieri as a Swiss guard, 1667–1669
oil on canvas, 130 x 94 cm
MR 1263

Room 4 - Great families
The Rospigliosi

Nicola Michetti
*Model of the Pallavicini Rospigliosi Chapel
in San Francesco a Ripa,* ca. 1712
various techniques and materials, 170 x 112 x 96 cm
Dep. Pall.1

The model of the chapel, built in the church of San Francesco a Ripa between 1710 and 1726, consists of elements that can be dismantled and substituted in order to present the different variations to the commissioners. The sculptural decoration in modelled wax testifies to the tradition of ceroplastics in the Roman workshops.

Room 5 - Great families
The Rospigliosi

Most of the images originating from the Rospigliosi collection are linked to commissions from Camillo, nephew of Maria Camilla Pallavicini, and document, between the 1740s and 1760s, his status as a property-owning noble, devoted to the supervision of agricultural activities and above all to farming on his vast estates. The Rospigliosi, in harmony with the European nobility's general process of re-feudalisation had strengthened their power by acquiring, in 1670, the Duchy of Zagarolo, whilst with the inheritance of Maria Camilla Pallavicini they had come to own the Maccarese estate.

Prince Camillo, a lover of racehorses and promoter of festivals and celebrations connected with the events and rhythms of rural life, embodied cultural customs in contrast with the courtly tastes of most of the nobility of the time, the Roman nobility in particular, and supported the commissioning of genre painting, which taken as a whole provides a unique proof of social behaviour and custom.

Room 5 - Great families
The Rospigliosi

Agostino Masucci
Equestrian portrait of Camillo Rospigliosi, 1737
oil on canvas, 220 x 147 cm
MR 765

This portrait is the only official image of Camillo Rospigliosi. The choice of equestrian portrait, although recalling seventeenth-century courtly models, from Rubens to Van Dyck, in the precise description of the gait of the horse, its harness and the details of Camillo's clothing, is a faithful document regarding the contemporary art of riding.

Johan Reder
Nocturnal festival for the return of the "mozzatore" held in Prince Rospigliosi's garden on 18 October 1748, ca. 1748
oil on canvas, 123 x 173 cm
MR 593

Held in the internal garden of the small seventeenth-century palace on the Esquiline, the popular festival of the "mozzatore", the female farm hands returning from the grape harvest, became a fashionable entertainment for the circle of the noble non-conformist Camillo Rospigliosi.

Room 5 - Great families
The Rospigliosi

Adrien Manglard
Festival at Maccarese in honour of Saint George on 1 May 1756,
ca. 1756
oil on canvas, 156 x 232 cm
MR 3339

This painting commemorates the feast of Saint George in 1756, celebrated perhaps with particular solemnity in order to inaugurate the initiatives to restore the palace and the chapel on the Maccarese estate which Camillo, who had taken over from his father after his death in 1752, set underway that same year.

Room 5 - Great families
The Rospigliosi

Camillo Rospigliosi's passion for racehorses, bred on the estates of Zagarolo and Maccarese, is documented in a unique collection of horse portraits, almost all of which were commissioned from Johan Reder, who for Camillo's father had painted scenes of country life and hunting for the family's homes.

In the horse portraits, the documentary quality is heightened by the inclusion, in the image, of poetic texts which identify the animal and describe its merits.

There is, in addition, a production of further poetic and prose texts, handed down by means of engravings or decorated manuscripts, dedicated to the most famous horses and to the celebration of their victories. The festivals in honour of the prince's favourites were often held in his secondary residence, near Santa Maria Maggiore. In the internal garden of the small palace Camillo had a carousel built with carved and painted wooden horses, which was used for fashionable entertainments, often celebrated by poetical and musical compositions. A contemporary inventory mentions a sort of ornament-cum-plaything which the prince had commissioned to be set up in the Palace at the Quirinal: a puppet theatre of wax figurines depicting the traditional Barbary horse race which was held at the Carnival Procession.

Johan Reder
Stallion with groom, ca. 1762
oil on canvas, 49 x 63 cm
MR 771

This, like many other portraits of horses with their grooms, intended to record pedigrees, are linked to the technical-scientific illustration of handbooks on the horse which had been published in Europe since the sixteenth century.

Room 7 - Great families
The Rospigliosi

Johan Reder
Flight of the Barbary horse Falcone, ca. 1764
oil on canvas, 49 x 63 cm
MR 766

The *Flight of the Barbary horse Falcone,* an episode which took place in April 1764, is narrated with an accentuated anecdotal spirit. The taste for detailed information shown by this figurative production, corresponds to the contemporary rise of printed periodicals.

Johan Reder
The cat, ca. 1750 - 1769
oil on canvas, 76 x 62.5 cm
MR 962

Falling within Camillo Rospigliosi's singular non-conformism in terms of culture and custom is a poetic production of entertainment, also recorded in the graphic collection housed in the Museum of Rome. This particular expression of fashionable courtship, entrusted with surprising irony to the portrait of a cat, belongs to this representative and celebrative code.

Room 6 – Exoticism and decorative arts
Chinoiserie

The taste for *chinoiserie*, a western interpretation of decorative motifs of oriental derivation, became widespread from the seventeenth century, before being fully manifested in the course of the eighteenth century. Thanks to the facility with which medium-size objects could be transported and marketed, products of the minor arts became the principal vehicle for the diffusion of motifs à *la façon de Chine*.

In the eighteenth century far-eastern typologies and techniques multiplied especially in artefacts made of ceramic and porcelain, the secret of whose manufacture had been fully discovered, and in furniture for whose decoration processes other than lacquers had been introduced, such as the French Vernis Martin or the counterfeit Venetian lacquer.

The fabrics, for the most precious of which preference was given to silk, a fibre originating from China which for centuries had come to Europe with the caravans on the so-called "silk routes", were enriched with clearly orientalising decorations.

At the beginning of the eighteenth century, the taste for interior decoration also absorbed the repertoire of *chinoiserie*, which invaded noble residences throughout Europe, supplementing the Rococo code and establishing an exotic set of samples destined to survive for more than two hundred years.

The Chinese Room in Palazzo Braschi, probably created in the mid nineteenth century, is a singular example of the persistence and transformation of exoticising stylistic features and themes in the nineteenth century.

The complex embroidery of arabesque and stylised forms on the ceiling, which eclectically reinterprets the Rococo caprices of the small Chinese rooms of the mid eighteenth century, is completed by the theatrical illusionism of the false lattice work with exotic birds painted on the walls, which alternate with neutral spaces for the hanging of oriental paintings or prints.

Room 6 – Exoticism and decorative arts
Chinoiserie

Man's formal waistcoat, ca. 1790
MR 3525

This waistcoat, made of green silk *satin*, with a shot effect and embroidered in polychrome silks, manifests its allusion to the orient in the small scenes of exotic taste. However, the orientalising references appear to be mitigated by the simplified and linear style, which indicates a date in the 1790s.

Woman's formal dress (Robe à la française), 1770-1780
MR 7109

This *andrienne* has hand-painted decoration, on a background of white silk with polychrome floral and meandering motifs, and is embroidered with spangles, small modelled metallic studs and lamellated metallic thread. The decoration comes very close, in terms of its realisation technique and the optical effect, to the "Indians", printed cotton fabrics originating from India – which were very common in eighteenth-century Europe – and produced, in particular, in Genoa.

Room 8 – Great families
The Torlonia

This family, originating from Puy-de-Dôme, in France, had moved to Rome in around 1750. Marino Torlonia had begun a thriving commercial activity, laying the foundations for what would be the family's enormous economic success, but the founder of the Torlonia wealth was Giovanni (Siena 1755-Rome 1829), a skilful businessman and banker for many members of the Roman aristocracy who, taking advantage of the vicissitudes of the Papal State during the Napoleonic period, accumulated enormous riches. Giovanni had five children: Maria Teresa, Marino, Carlo, Alessandro and Maria Luisa.

Alessandro (Rome 1800-1886), may be considered to be the true heir of his father's skill and the continuator of the

cultural leanings and policy of the founder of the family.

The Torlonia residence in Piazza Venezia was one of the most prestigious houses of the Roman nobility in the first half of the nineteenth century. The palace, formerly belonging to the Bolognetti, had been acquired by the Torlonia family in 1807 and, at the behest of Giovanni Torlonia, was converted by Giovanni Battista Caretti (1803-1898) into a luxurious dwelling, a tangible symbol of the constantly expanding economic success of the princes-bankers. The most celebrated artists of the time were summoned to decorate the building, including Berthel Thorvaldsen, Pietro Gagliardi, Filippo Bigioli, Pietro Galli and Francesco Podesti. The latter painted a series of *Stories of the gods,* in the so-called Canova Wing, designed to house the monumental group by the Veneto sculptor, depicting *Hercules and Lichas.*

The sumptuous Palace was the venue for prestigious receptions in which representatives of the aristocracy and exponents of the intellectual world took part.

Salvaged from the demolition of the building, which took place in 1902, many of the furnishings and decorative parts ended up on the antiques market and were dispersed. In the 1930s, a collection of paintings, furniture and artefacts of various techniques, originating from the palace, were acquired by the museum of Rome and, overall, contribute to defining the contemporary taste for interior decorations.

Room 8 – Great families
The Torlonia

Francesco Podesti
Portrait of Proserpine, ca. 1836-1837
charcoal drawing with white chalk highlights
1800 x 3200 mm
MR 16987

Proserpine corresponded in Greek mythology to Persephone and was the daughter of Jupiter and Ceres. She was carried off by Pluto, god of the Underworld, who had become infatuated with her beauty; the drawing shows Proserpine, seized by Pluto, asking in vain for help from her Nymphs.

Francesco Podesti
Toilet of Venus, ca. 1836-1837
charcoal drawing with white chalk highlights
1790 x 3085 mm
MR 16985

Venus, Aphrodite for the Greeks, was the goddess of beauty and the symbol of beauty and love. The goddess represented pure and ideal love but also sensual love; on account of having begotten Aeneas by Anchises, Venus was also considered to be the ancestress of the gens Julia.

Room 8 – Great families
The Torlonia

Francesco Podesti
Judgement of Paris, ca. 1836-1837
graphite drawing with white chalk highlights
1800 x 3115 mm
MR 16989

This drawing depicts the very famous episode in mythology of which Paris, son of Priam was the protagonist, called on to express his judgement as to who was the most beautiful of the goddesses, Juno, Venus and Minerva. The young man chose Venus, awarding her the apple of discord and making eternal enemies of the two he excluded.

Francesco Podesti
Rape of Europa, ca. 1836-1837
graphite drawing and white chalk highlights
1880 x 3110 mm
MR 16990

The episode of the rape of Europa is one of the most famous in the *Metamorphoses:* Jove, having become infatuated with the nymph, turned himself into a bull, abducted her and took her to Crete. This drawing depicts the culminating episode of the story when Europa, on the back of the bull, is led away surrounded by cupids.

Room 8 – Great families
The Torlonia

Antonio Canova, (attributed)
Antonio Canova shows Giovanni and Anna Maria Torlonia the sketch for Hercules and Lichas, ca. 1811
oil on canvas, 30.3 x 36.7 cm
Dep. GAA 130

The artist is portrayed in the act of showing Giovanni Torlonia and his wife Anna Maria, with their children, the sketch depicting the group of *Hercules and Lichas*. In the Palace of the illustrious commissioners, a specially designed and decorated gallery was set aside for Canova's monumental creation.

Pietro Fontana (eng.), **Giovanni Tognoli** (des.), **Antonio Canova** (inv.)
Hercules and Lichas, 1812
Etching and burin on paper, trimmed margins, 520 x 377 mm
MR 16340

This translated print was taken from the group of *Hercules and Lichas* by Antonio Canova, acquired by the Torlonia family and housed in the family palace. The hero is seen here from the back, in the act of hurling, in his frenzy, Lichas into the sea.

Room 9 – Great families
The Torlonia

Acquired by Giovanni Torlonia in 1820, the Apollo Theatre was inherited by his son Alessandro who entrusted its first restoration to Giuseppe Valadier.
At the end of the 30s new restorations were carried out under the direction of the architect Quintiliano Raimondi, who enriched with new decorations the ambulatories, the café and the very lavish Torlonia apartment, adjacent to the theatre's fourth order.
It is from this Theatre, demolished in 1889 for the construction of the Tiber embankments, that the twelve lunettes depicting the months of the year originate. Painted by Filippo Bigioli in around 1839, they decorated the elliptical room in the Theatre which led to the Torlonia apartment.
The doors painted in ivory and gold, on the other hand, date back to the restoration interventions of 1862, carried out by the Commune of Rome, which, at the time, had rented the Apollo theatre from the Torlonia family.

Pietro Gagliardi
Apollo and the Hours, ca. 1844
charcoal drawing with white chalk highlights
3510 x 2115 mm
MR 2303

This drawing is the preparatory cartoon for the fresco which Pietro Gagliardi executed in the Villa Carolina in Castel Gandolfo at the behest of Don Marino Torlonia. Here the painter reveals his inclination towards classicist painting and his artistic training, modelled on the great masters of the sixteenth century.

Room 9 – Great families
The Torlonia

Filippo Bigioli
The Months, 1839
tempera on canvas, each lunette 56 x 106 cm
January, MR 45703
May, MR 45707
August, MR 45710
December, MR 45714

The classical-purist training of Bigioli, who from 1835 collaborated on the decorations of the Torlonia villa on the Via Nomentana and the palazzo in Piazza di Venezia, is expressed in the Arcadian-naturalistic interpretation of the allegories of the months, suggested by Cesare Ripa's *Iconologia*, a fundamental text for the humanistic culture of the sixteenth century.

Room 10 – Great families
The Torlonia

The so-called "Alcove" originating from the demolished Palazzo Torlonia in Piazza Venezia is an incomplete reconstruction of the reception room which preceded the actual bedroom.
The current complex structure was sal-

antiquarian Francesco Tancredi and put up for sale in 1903. Acquired by the Museum in the 30s, it was reassembled in 1952 on the second floor of Palazzo Braschi and in 2000 was the subject of a careful restoration intervention which has restored to the whole the preciousness of a treasure chest. In 1837 Filippo Bigioli (1798-1878) was entrusted with the pictorial decoration of the setting. In the small room, "painted in the manner of the ancient thermal baths", the artist depicted the *Judgement of Paris* in the tondo at the centre of the ceiling, which was presumably framed by the *Loves of the gods* in sixteen small squares, ovals and hexagonals, now lost. In the four pendentives below appear the chariots of gods symbolising the elements of the cosmos: Vulcan for fire, Juno for air, Ceres for earth and Neptune for water.

The stuccoes and reliefs on the walls, the pilasters adorned with gilded arabesques, the friezes, coats of arms and medallions with the *Stories of Psyche* were realised by Pietro Galli (1804-1877), a pupil of Thorvaldsen.

The small tondoes depicting birds of every kind, at the base of the false niches with monochrome female figures by Bigioli, are due to Alessandro Mantovani (1814-1892).

vaged, together with other elements of the decorations and the furnishings originating from Palazzo Torlonia, by the Neapolitan

Room 10 – Great families
The Torlonia

Filippo Bigioli
Judgement of Paris inside a pavilion motif with grotesque ornaments, ceiling of the so-called Torlonia "Alcove", ca. 1837
tempera on canvas
MR 45204

Room 11 – Great families
The Giustiniani Bandini and the Brancaccio

Among the last great Roman commissioners and patrons were the Giustiniani Bandini and the Brancaccio families.
The former were resident at Palazzo Vidoni and, from the early twentieth century, in a small villa in Via Virginio Orsini in the Prati district, whilst the latter, since the 1880s, lived in a palazzo in Via Merulana, especially built for the family. A branch of the Giustiniani family, originally from Genoa, had settled in the fourteenth century on the island of Chios, where it had made its fortune through the trade of mastic and alum. In 1566 Giuseppe Giustiniani, hotly pursued by Turkish pressures, had moved to Rome, taking with him his great wealth. His two sons, the marquis Vincenzo and cardinal Benedetto, assembled one of the most famous collections of the age, which also included works by Caravaggio.
Andrea, nephew and heir of the marquis, married Marietta Pamphilj, niece of pope Innocent X, receiving with the large estate of Bassano the title of prince. In 1757 Benedetto Giustiniani, son of Girolamo Vincenzo and Anna Maria Ruspoli, married Cecilia Mahony countess of Newburgh, obtaining the title for all his descendants.
The Bandini family, on the other hand, who had settled in Camerino in 1280, were marquises of Lanciano and Rustano. In 1813 Carlo Bandini married one of the most courted young ladies in the Roman aristocracy, Cecilia, heir of Don Vincenzo Giustiniani. This union gave rise to the Giustiniani Bandini family, which, in 1863, acquired the title of the extinct Giustiniani family. In 1870, Mary Elisabeth Field, daughter of a New York magnate, married prince Salvatore Brancaccio di Triggiano, heir of one of the oldest families in the Neapolitan nobility. Since the eleventh century, in fact, his family had been documented among the big landowners of the Kingdom of Naples. As of 1879, the wealthy princess established close relations with Francesco Gai, who became her trusted artist and portrait painter. Although having commissioned the design for the extension for her house in Via Merulana from the architect Luca Carimini, she entrusted the painter with the design of the furnishings and decorations of the interior, according to her personal neo-rococo taste. The princess' mother, Mary Elisabeth Bradhurst Field, a well known protagonist in contemporary Roman fashionable life, financed the mosaic by Burne Jones which decorates the apse of the American Anglican-Episcopal church of St. Paul's Within the Walls, in Via Nazionale.

Room 11 – Great families
The Giustiniani Bandini and the Brancaccio

Filippo Agricola
Portrait of Giovanna Massani, ca. 1840
graphite and pastel on paper, 600 x 520 mm
MR 38900

Giovanna, eldest daughter of Giuseppe Massani, led a stormy life full of adventures and made a second marriage to the violinist Tullio Ramacciotti. The drawing depicts her when she was still a girl and is a demonstration of Filippo Agricola's study of and adherence to Raphaelesque ideals, as well as a testimony of the friendship existing between the artist and the Massani family.

Bertel Thorvaldsen (?)
Bust of Maria Massani, ca. 1838
white Carrara marble, height 60 cm
MR 36492

Adolescent portrait of Maria Massani, later princess Giustiniani Bandini in which the naturalistic rendering of the subject is compounded by the ideal precision of the modelling. The Massani family owned various works by artists revolving in the circle of neoclassicism and Roman purism, dominated in those years by the sculptor Thorvaldsen, to whom the sculpture can be attributed.

Room 11 – Great families
The Giustiniani Bandini and the Brancaccio

Francesco Gai
Portrait of princess Elisabeth Brancaccio, 1879
oil on canvas, 26.8 x 20.8 cm
MR 18419

The chronicles of the time mention princess Elisabeth Field Brancaccio as being "among the most attractive ornaments in the Court of Her Majesty the Queen". The portrait is very similar to the one which depicts her with her children in the palace garden, even though the white frills and soft curls give this small painting a brighter and lighter chromatic effect.

Francesco Gai
Princess Elisabeth Brancaccio with her children in the palazzo garden, 1884
oil on canvas, 310 x 390 cm
MR 18430

Life-size portrait of princess Brancaccio with her children in the exotic park of the palazzo, a veritable jardin d'acclimatation with rare botanical species. At the behest of the commissioner the composition is inspired by the painting *L'enfant chéri* by Fragonard and Marguerite Gérard, from which the typically eighteenth-century gracefulness derives.

Room 11 – Great families
The Giustiniani Bandini and the Brancaccio

Francesco Gai
King Umberto and Queen Margherita of Savoy on a visit to the Brancaccio princes, 1886
oil on paper glued onto panel, 32.3 x 51.5 cm
MR 18428

This sketch is a study for a painting, which was never completed, of the reception given on 22 May 1886 by the Brancaccio princes in honour of King Umberto and Queen Margherita. The painter's intention is to re-evoke the atmosphere of private entertainment rather than the official aspect of the occasion.

Room 12 – Society in focus
The photographic portrait

For centuries the portrait was the perquisite of painting and the prerogative of the ruling classes. The photograph, on its introduction, maintained a continuity with the pictorial tradition: it followed compositional schemes guided by the rules of perspective and constructed the space by entrusting a role of the foremost importance to tonal and chiaroscuro relations.

This period is characterised by the great studio portraits composed with meticulous and careful poses, as in paintings, with the protagonists caught in a static position, immobile for the long time necessary for exposure and surrounded by objects which corresponded to a very precise *mise-en-scène*.

On the other hand, however, the spread of photography, which took place in parallel with industrial progress, economic growth and the consequent rise of the middle class, made the portrait a very common and economically accessible practice, which offered

ence of the albumen gave contemporary photos a particularly brilliant gloss which, in conjunction with the rich colouring of intense brown shades, constitutes their principal characteristic.

The typologies most in demand for portraits were the cabinet format, so called because the image was mainly created in a photographic studio and the even smaller *carte-de-visite*, used as the name suggests as a visiting card for mutual exchange. These photos were often glued onto a cardboard backing which advertised the name of the photographer and lent itself to adding a few lines of dedication. A veritable cult for photographic portraits thus originated, often collected in albums and preserved in large numbers in aristocratic or middle-class homes. The portrait created in the studio was later joined by open-air shots of posed groups of people and, as familiarity with photographic images increased, so the types of subjects treated became more varied.

Towards the end of the nineteenth century the profession of photographer was established as being fully autonomous and the popularising of the more modern technique using gelatin silver bromide, which also lent itself to industrial preparations, allowed photography to spread enormously. As a consequence, the portrait was no longer only a static representation of eminent personages, but became an instrument for documenting various aspects and the various phases of family and fashionable life, as well as social rituals.

the new social classes, too, the possibility of self-representation. As early as 1860 the collodion technique for the preparation of the glass plate used as a negative was widespread, which drastically reduced exposure times, facilitating shots of the human figure and favouring the production of images of a smaller format, whose reduced size made them easier to circulate.

The paper used for photographic prints was treated with egg albumen; the pres-

Room 12 – Society in focus
The photographic portrait

Antonio and Paolo Francesco D'Alessandri
Umberto I of Savoy, post 1878
albumen
AF 7786

The young king (1844-1900), who had ascended to the throne on the death of Vittorio Emanuele II in January of 1878, is portrayed in official dress by the D'Alessandri brothers with the well known skill they had already demonstrated as photographers of the papal court. The fame they had achieved allowed them to maintain a vast clientele even after the unity of Italy, despite their link with the past regime.

Luigi Primoli
Prince Napoleon Victor Bonaparte, ca. 1891
albumen
AF 1648

Luigi Primoli was the cousin on his mother's side of Napoleon Victor Bonaparte (1862-1926), son of Jerome Napoleon and Clotilde of Savoy and, as such, heir to the title of Imperial Highness; he portrays his illustrious relation by the bust of Napoleon by Chaudet inside his own palace, which was the stage both for his photographic experiences and for his encounters with the intellectual and cosmopolitan world of *fin-de-siècle* Rome.

Room 12 – Society in focus
The photographic portrait

Henri Le Lieure De L' Aubepin (attributed)
Lady from behind in Renaissance costume, ca. 1870-1880
gelatin silver bromide
AF 8308

This composition reveals a degree of experience and skill such as to consent its attribution to the great photographer, who often portrayed personages in costume in the masquerades organised in Rome in the last quarter of the nineteenth century. The shot from behind shows more attention to the pictorial layout than to the face of the person portrayed, freeing the portrait from the simple re-proposal of the features of the protagonist.

Francesco Paolo Michetti (attributed)
Table for artists with model in sixteen different poses
ca. 1880-1890
gelatin silver bromide
AF 267

One of the most fascinating aspects of the late nineteenth-century artistic scenario is the relationship between painting and photography, which was no longer perceived as an antagonist of painted works, but as a valid support. Many artists, including Michetti, decided to move closer to the new technique in order to derive models from it for their works, demonstrating at the same time a great aptitude for photographic rendition.

Room 12 – Society in focus
The photographic portrait

Domenico Rocchi (attributed)
Group of pensionnaires from the Academy of France at Villa Medici 1863-1864
albumen
AF 538

Members of this group have been identified as Jean Victor Schnetz, director of the Academy of France from 1841 to 1846 and then from 1853 to 1866 and the musician Jules Emile Frédéric Massenet (1842-1912), Prix de Rome at only 21 years of age in 1863-1864, which makes it possible to date the photograph to this period.

Teodoro Fabbri
Group photo of the Association of German artists on a trip to the Serpentara on the first of May 1897, 1897
albumen
AF 7856

The large group on an outing to the Serpentara woods near Olevano Romano also includes several German artists linked to the so-called school of Olevano.
The subjects are portrayed at the monument which records the fiftieth anniversary of the foundation of the Deutschen Künstlerverein (1845-1895).

Room 12 – Society in focus
The photographic portrait

Gioachino Altobelli or Enrico Verbaschi (attributed)
Participants in the First Italian Juridical Congress in the courtyard of Palazzo dei Conservatori in Campidoglio
8 December 1872
albumen
AF 530

In this photo, taken near the bronze head of the colossal statue of Constantine, it is possible to recognise at the bottom centre Francesco Carrara, Ubaldino Peruzzi and Urbano Rattazzi. This work is referable to the period of collaboration between Verzaschi and Altobelli (until circa 1875), who demonstrated a lively aptitude for group portraits somewhat ahead of their time.

Henri Le Lieure De L' Aubepin

Members of the International Artistic Circle at the Aesthetic Convention masquerade in the courtyard of Palazzo Patrizi
25 February 1900
gelatin silver bromide
AF 802

The painter Attilio Simonetti in Renaissance dress
25 February 1900
gelatin silver bromide
AF 807

Ladies in cyclamen, lilac and lily of the valley costumes
25 February 1900
gelatin silver bromide
AF 797

Series of photographs of the masquerade entitled the *Aesthetic Convention*, devised by Attilio Simonetti (1843-1925) for the International Artistic Circle and inspired by works of art from the fifteenth to the nineteenth century. It was presented on 24 February 1900 at the Costanzi theatre and re-presented the day after at the seat of the Artistic Circle in Palazzo Patrizi, in Via Margutta, in whose garden adorned with ancient sculptures these portrait pictures were taken.

Room 12 – The fashion code
The nineteenth century

As in the previous century, in the nineteenth century fashion innovations spread rapidly, offering a homogenous and uniform picture throughout Europe.

After the first years of the century, characterised by the high waistline under the breast, the typically Romantic style was established, with the return of models with a well defined structure: first of all the waistline returned to its natural place and then dropped slightly below this; bodices became tight fitting and boned once again; skirts filled out thanks to the use of new types of substructures which replaced the eighteenth-century panniers. The most representative element of the nineteenth century is the *crinoline* – a substructure made of horsehair – which subsequently became a proper cage made of metal or rush hoops.

In the fifties the crinoline cage, the evolution of the bell skirt fashionable in previous years, began to reach the enormous sizes of the years '55 -'60, which could even be as much as seven metres in circumference.

It was Worth, the first real creator of fashion in the modern sense who, aware of the impossibility of further expanding the lower part of the dress, decided to launch a model with a skirt that was flattened at the front and expanded at the back, which took the name of *demi crinoline*. This new fashion at the end of the sixties of the century was reduced to a sort of half cage, giving rise to the process of verticalisation of the female *silhouette*. It was not long before the skirt was enriched with decorations and variously draped panels of cloth, which created a binding and animated effect at the same time, characterising the fashion of the second half of the seventies.

At the end of the '80s the development process of the rigid substructure was completed: the time was ripe for it to be done away with. A more natural line took concrete form in the flared shape of the skirt, which was more functional and modern and already foreshadowed the rise of the fashions typical of the *Belle Epoque*.

Woman's day dress, 1850-1860
MR 45320

The style of this silk taffeta dress with a tight-fitting bodice in a shade of yellow ochre and a domed skirt with a tartan motif, denotes a type of tailoring of the decade 1850-1860, when women's fashion was characterised by the presence of the *crinoline*. The typical values of the middle class are expressed, in this garment, in the quality of the cut and in the sober harmony of the colours.

Room 12 – The fashion code
The nineteenth century

Bridal gown, 1884
MR 45352

This ivory colour silk gown reflects the taste established in the 1880s. The style and the colour would suggest it was intended to be worn at a wedding, for which, after the institution of the cult of the Immaculate Conception, in 1854, the use of white was codified and became traditional. It may perhaps be the bridal gown donated to the Museum by the heirs of Adelina Ferrari who, in Parma in 1884, married Alberto del Bono, at the time a Naval Officer and minister of the Navy from 1917 to 1919.

BIBLIOGRAPHY

FOREWORDS

This bibliography lists in chronological order the main publications which concern Palazzo Braschi and the history of the Museum of Rome and those which illustrate the collections in the Museum. For the period 1929-1970 readers should consult the bibliography published in: C. Pietrangeli, Il Museo di Roma: documenti e iconografia. Bologna, Cappelli, 1971.
The bibliography relating to individual works is published in the catalogue for the exhibition Il Museo di Roma racconta la città, edited by R. Leone, F. Pirani, M.E. Tittoni, S. Tozzi. Rome, Gangemi, 2002

Works on Palazzo Braschi

C. Pietrangeli, *Palazzo Braschi*. Rome, Istituto di Studi Romani, 1958

Palazzo Braschi e il suo ambiente, edited by C. Pietrangeli and A. Ravaglioli. Rome, Edizioni di Capitolium, 1967

E. Ricci, *Palazzo Braschi. Storia ed architettura di un edificio settecentesco*. Rome, Palombi, 1989

R. Leone, *Cultura dell'abitare e gusto decorativo a Palazzo Braschi, 1*. In: "Bollettino dei Musei Comunali di Roma", n.s., 11 (1997), p. 67-92

M.E. Giralico, M.J. Mano, U. Santamaria, G. Tamanti, *Un cantiere scuola dell'Istituto Centrale del Restauro: la "Veduta di Nemi" di Liborio Coccetti*. In: "Bollettino dei Musei Comunali di Roma", n.s., 11 (1997), p. 171-179

R. Leone, *Cultura dell'abitare e gusto decorativo a Palazzo Braschi, 2*. In: "Bollettino dei Musei Comunali di Roma", n.s., 12 (1998), p. 45-73

A. Margiotta, M.G. Massafra, *Un percorso fotografico a Palazzo Braschi 1870-1987*. Rome, Gangemi, 2002
Palazzo Braschi. *Immagini di un restauro*, edited by L. Funari. Rome, Kappa, 2002

Works on the Museum of Rome and its collections

A. Muñoz, *Il Museo di Roma*. Rome, Governorship of Rome, 1930

A. Muñoz, *Catalogo della mostra delle opere di Bartolomeo Pinelli*, Roma, Museo di Roma, aprile-maggio, 1935

Mostra delle opere lasciate al Comune di Roma dal pittore Guglielmo De Sanctis (1829-1911), Rome, Capitoline Museums, April 1949. Rome, s.n., 1949

Mostra della fotografia a Roma dal 1840 al 1915, Rome, Museum of Rome, 1953. Rome, Ente Provinciale per il Turismo, 1953

Mostra delle novità dei musei comunali: acquisti, ritrovamenti, restauri, Rome, Museum of Rome, May 1954. Rome, Palombi, 1954

Mostra delle opere donate ai musei del Comune di Roma negli anni 1951,1952, 1953, Rome, Museum of Rome, May 1954. Rome, Palombi, 1954

R. Righetti (edited by), *Gemme e cammei delle collezioni comunali*. Rome, Department X of the Commune of Rome, 1955

Mostra di Benedetto Pistrucci (1784-1855),

Rome, Palazzo Braschi, 10 December 1955 – 10 January 1956. Rome, Istituto Poligrafico dello Stato, 1955

Mostra di vedute romane appartenenti alla raccolta del Barone Basile de Lemmerman, Rome, Palazzo Braschi, May - June 1955. Rome, Ente Provinciale per il Turismo, 1955

G. Incisa della Rocchetta (edited by), *Bartolomeo Pinelli*, exhibition catalogue, Rome, Palazzo Braschi, 1956. Rome, Istituto Grafico Tiberino, 1956

Da Villa Ludovisi a Piazza Barberini, exhibition catalogue edited by C. Pietrangeli, Rome, Palazzo Braschi, October - December 1957. Rome, Istituto Grafico Tiberino, 1957

La raccolta di acquerelli di Bartolomeo Pinelli donati dal Barone Basile de Lemmerman al Comune di Roma, edited by G. Incisa della Rocchetta. Rome, Istituto Grafico Tiberino, 1958

Mostra degli acquerelli di Achille Pinelli recentemente acquistati dal Comune di Roma, exhibition catalogue, Rome, Art gallery at the Palazzo delle Esposizioni, January 1958. Rome, Tipografia Centenari, 1958

Seconda mostra delle novità dei musei comunali: acquisti, doni, restauri (1955-1959), Rome, Museum of Rome, 18 – 25 October 1959. Rome, Tipografia Centenari, 1959

Vedute della Campagna Romana. Incisioni e disegni donati al Museo di Roma dal barone Basile de Lemmerman, exhibition catalogue edited by F. Pansecchi, Rome, Palazzo Braschi, December 1964 – January 1965. Rome, De Luca, 1964

Novità dei Musei comunali: acquisti, doni, restauri 1959-1964, exhibition catalogue edited by C. Pericoli Ridolfini, Rome, Palazzo Braschi, 1965. Rome, Istituto Grafico Tiberino, 1965

Museo di Roma. Itinerario, edited by A.M. Colini, C. Pietrangeli, C. Pericoli Ridolfini. 2. ed. Rome, s.n., 1966

Villa Borghese, exhibition catalogue edited by A. Giovanetti, G. Di Domenico Cortese, P. Hoffmann, C. Pietrangeli, Rome, Palazzo Braschi, December 1966 – January 1967. Rome, De Luca, 1966

Vedute romane di Achille Pinelli (1809-1841), exhibition catalogue, Rome, Palazzo Braschi, 17 June - July 1968. Rome, De Luca, 1968

Roma cento anni fa nelle fotografie del tempo, exhibition catalogue edited by P. Becchetti, L. Cavazzi, G. Incisa della Rocchetta, C. Pietrangeli, Rome, Palazzo Braschi, 17 December 1970 –17 March 1971. Rome, Romagrafik, 1971

C. Pietrangeli, *Il Museo di Roma: documenti e iconografia*. Bologna, Cappelli, 1971

Vedute romane di Stefano Donadoni (1844-1911), exhibition catalogue edited by G. Incisa della Rocchetta, Rome, Palazzo Braschi, December 1972. Rome, Palombi, 1972

Roma Giacobina, exhibition catalogue edited by M.E. Tittoni and L. Cavazzi, Rome, Palazzo Braschi, 18 December 1973 – 31 January 1974. Rome, Tipografia Centenari, 1973

G. Incisa della Rocchetta, *Gregorovius, Roesler Franz e il Museo di Roma*. In: "Bollettino dei Musei Comunali di Roma", 12 (1975), p. 33-39

G. Incisa della Rocchetta, *Le mostre a*

Palazzo Braschi e il Museo di Roma. In: "L'Urbe", n.s. 39 (1976), p. 1-4

Roma sparita. Mostra di disegni e acquerelli dal sec. XVI al XX dalla donazione della Contessa Anna Laetitia Pecci Blunt al Museo di Roma, exhibition catalogue edited by G. Incisa della Rocchetta, L. Cavazzi, M.E. Tittoni, R. Varoli-Piazza, Rome, Palazzo Braschi, March – April, 1976. Rome, Palombi, 1976

G. Incisa della Rocchetta, *Nuove schede per il catalogo delle opere di Achille Pinelli nel Museo di Roma*. In: "Bollettino dei Musei Comunali di Roma", 24 (1977), p. 79-88

Roma dei fotografi al tempo di Pio IX (1846 – 1878). Fotografie da collezioni danesi e Romane, exhibition catalogue edited by P. Becchetti ...et al. , Copenhagen, Thorvaldsen Museum, 1977 - Rome, Palazzo Braschi, 1977. Rome, Multigrafica, 1977

Mostra delle opere del pittore Cesare Mariani (1826-1901) conservate nel Museo di Roma, catalogue edited by G. Di Domenico Cortese and L. Barroero. Rome, Palazzo Braschi, November - December, 1977. Rome, Palombi, 1977

"Fochi d'allegrezza" a Roma dal Cinquecento all'Ottocento, exhibition catalogue edited by L. Cavazzi, Rome, Palazzo Braschi, 15 September - 31 October 1982. Rome, Quasar, 1982

Luigi Rossini incisore. *Vedute di Roma 1817-1850,* exhibition catalogue edited by L. Cavazzi, M.E. Tittoni, Rome, Palazzo Braschi, 7 April -15 July 1982. Rome, Multigrafica, 1982

Una città di pagina in pagina. Fotografie e illustrazioni, exhibition catalogue edited by L. Cavazzi, R. Leone, A. Margiotta, R. Piccininni, S. Tozzi, Rome, Palazzo Braschi, January-March 1984. Venice, Marsilio, 1984

Pittori fotografi a Roma: 1845-1870. Immagini della raccolta fotografica comunale, exhibition catalogue edited by L. Cavazzi, A. Margiotta, S. Tozzi, Rome, Palazzo Braschi, 25 June - 27 September 1987. Rome, Multigrafica, 1987

L. Cavazzi - A. Margiotta, S. Tozzi, *L'incisione a Roma nel Cinquecento nella raccolta del Gabinetto Comunale delle Stampe.* Rome, Palombi, 1989

Un inglese a Roma: 1864-1877. La raccolta Parker nell'Archivio Fotografico Comunale, edited by L. Cavazzi, A. Margiotta, S. Tozzi. Rome, Artemide, 1989

Piranesi e la veduta del Settecento a Roma, exhibition catalogue edited by L. Cavazzi, A. Margiotta, S. Tozzi, Rome, Palazzo Braschi – Mogliano Veneto, Villa la Marignana-Benetton, 1989. Rome, Artemide, 1989

E.B. Di Gioia, *Museo di Roma. Le collezioni di scultura del Seicento e Settecento.* Rome, Palombi, 1990

Feste e spettacoli nelle piazze Romane, exhibition catalogue edited by L. Cardilli, Rome, Museum of Folklore, 1990. Rome, Istituto Poligrafico e Zecca dello Stato, 1990

O. Mazzucato, *Introduzione alla ceramica medioevale del Museo di Roma.* Rome, Palombi, 1990

T. Pasotto, *Un itinerario al Museo di Roma. La ceramica.* Rome, Palombi, 1990

Architettura del Settecento a Roma nei disegni della raccolta grafica comunale, exhibition catalogue edited by E. Kieven. Rome,

Palazzo Braschi, 24 September -10 November 1991. Rome, Carte Segrete, 1991

L. Cavazzi - A. Margiotta, S. Tozzi, *Vedute Romane del Seicento nella raccolta grafica comunale*. Rome, Palombi, 1991

Una collezionista e mecenate romana: Anna Laetitia Pecci Blunt, 1885-1971, exhibition catalogue edited by L. Cavazzi, Rome, Palazzo Braschi, 26 November 1991- 6 January 1992. Rome, Carte Segrete, 1991

La fotografia a Roma dal secolo XIX. La veduta, il ritratto, l'archeologia, atti del convegno organizzato dall'Archivio Fotografico Comunale, Rome, Palazzo Braschi, 12-13 December 1989. Rome, Artemide, 1991

C. Spetia, *I mobili del Museo di Roma. Stili, forme, tendenze dal XV al XIX secolo*. Rome, Palombi, 1991

R. Leone, *Il catalogo settecentesco del Museo Pio Clementino*. Rome, Palombi, 1992

A. Margiotta - M.G. Massafra, *La raccolta fotografica dell'Archivio Comunale. Autori e tecniche*. Rome, Palombi, 1992

Incisioni Romane dal 500 all'800 nella collezione Muñoz. Il catalogo informatizzato della raccolta grafica comunale, exhibition catalogue edited by L. Cavazzi, R. Leone, M.G. Massafra, Rome, Palazzo Braschi, 27 May - 4 July 1993. Rome, Carte Segrete, 1993

Acquerelli di Achille Pinelli. Un fondo recentemente restaurato, exhibition catalogue edited by M.G. Massafra, Rome, Palazzo Braschi, 3 June - 31 July 1994. Rome, Photolaser, 1994

G.B. Falda e i suoi divulgatori. Scenografie urbane di Roma barocca, exhibition catalogue edited by A. Margiotta, Rome, Palazzo Braschi, 3 December 1994 - 22 January 1995. Rome, Photolaser, 1994

Giuseppe Vasi incisore (1710-1782), exhibition catalogue edited by S. Tozzi, Rome, Palazzo Braschi, 30 September - 20 November 1994. Rome, Photolaser, 1994

Il paesaggio secondo natura. Jacob Philipp Hackert e la sua cerchia, exhibition catalogue edited by R. Leone and S. Tozzi, Rome, Palazzo delle Esposizioni, 14 July- 30 September 1994. Rome, Artemide, 1994

Per il nuovo Museo di Roma, 1., edited by V. Casale, L. Cavazzi, E.B. Di Gioia, R. Leone, A. Pinelli, E. Ricci, S. Susinno. In: "Bollettino dei Musei Comunali di Roma", n.s., 8 (1994), p. 178-185

Per il nuovo Museo di Roma, 2., edited by V. Casale, L. Cavazzi, E.B. Di Gioia, R. Leone, A. Pinelli, E. Ricci, S. Susinno. In: "Bollettino dei Musei Comunali di Roma", n.s., 9 (1995), p. 163-178

L. Pirzio Biroli Stefanelli, *"Avea il Marchese Sommariva una sua favorita idea...". 1. Opere di incisori romani documentate nella collezione Paoletti*. In: "Bollettino dei Musei Comunali di Roma", n.s., 9 (1995), p. 104-116.

Palazzo Braschi riscopre i suoi tesori, atti del convegno edited by V. Casale and L. Cavazzi, Rome, Protomoteca Capitolina, 2 - 3 February 1994. Rome, Archivio Guido Izzi, 1995

A. Margiotta - M.G. Massafra, *Arte e tecnica dell'incisione nella raccolta grafica comunale*. Rome, Palombi, 1995

L. Pirzio Biroli Stefanelli, *Opere di Benedetto Pistrucci nel Museo di Roma*. Rome, Palombi, 1995

Acquisti e doni nei Musei comunali 1986 – 1996, exhibition catalogue edited by M. Dell'Era, F. Pirani, M. Rovigatti, Rome, Palazzo delle Esposizioni, 12 September - 21 October 1996. Rome, Progetti Museali Editore, 1996

Kissner & Roma. Un fondo bibliografico informatizzato del Gabinetto Comunale delle Stampe (sec. XVI - XIX), exhibition catalogue, Rome, Palazzo Braschi, 29 March – 2 June 1996. Rome Artemide, 1996

La festa a Roma dal Rinascimento al 1870, exhibition catalogue edited by M. Fagiolo. Rome, Palazzo Venezia, 23 May – 15 September 1997. 2 v. Turin, Allemandi, 1997

L. Pirzio Biroli Stefanelli, *"Avea il Marchese Sommariva una sua favorita idea...". 2. Le incisioni di Giovanni Beltrami.* In: "Bollettino dei Musei Comunali di Roma", n.s., 11 (1997), p. 111-131

Piranesi and the XVIII century view of Rome, edited by L. Cavazzi, A. Margiotta, S. Tozzi. Rome, Artemide, 1998 (English translation of the catalogue to the exhibition held in Rome, Palazzo Braschi and in Mogliano Veneto in 1989)

Severini al Foro Italico, exhibition catalogue edited by F. Pirani and S. Tozzi, Rome, Foro Italico - Palestra dell'ISEF, 20 July – 16 September 1998. Rome, Palombi, 1998

M.E. Tittoni, *L'alcova a Palazzo Braschi: dalla dispersione all'acquisizione nelle collezioni del Museo di Roma,* in "Filippo Bigioli e la cultura neoclassico-romantica fra le Marche e Roma", exhibition catalogue edited by G. Piantoni, San Severino Marche, Palazzo di Città, 18 July-11 October 1998. Rome, De Luca, 1998, p.44-48

Rome au XIX siècle. Photographies inédites 1852-1890, catalogue edited by A. Margiotta and S. Tozzi. Paris, Musée Carnavalet, 19 June - 5 September 1999. Rome, Palombi, 1999

M. Papini, *Palazzo Braschi: la collezione di sculture antiche.* Rome, «L'Erma» di Bretschneider, 2000

A. Aletta, M. Monticelli, *Volumi antichi. Libro aperto sulla città.* Rome, Gangemi, 2002

Carlo Fontana: L'anfiteatro Flavio. Edizione anastatica del manoscritto nel Museo di Roma, edited by H. Hager. Rome, Gangemi, 2002

F. Del Prete, *Il fondo fotografico del piano regolatore di Roma 1883. La visione trasformata.* Rome, Gangemi, 2002

B.E. Di Gioia, *Le collezioni di scultura del Museo di Roma: il Seicento.* Rome, Campisano, 2002

Il Museo di Roma racconta la città, exhibition catalogue edited by R. Leone, F. Pirani, M.E. Tittoni, S. Tozzi. Rome, Palazzo Braschi, 4 May 2002. Rome, Gangemi, 2002

S. Tozzi, *Incisioni barocche di feste e avvenimenti. Giorni d'allegrezza.* Rome, Gangemi, 2002

Scenari della memoria. Roma nella fotografia 1850-1900, edited by M.E. Tittoni and A. Margiotta. Milan, Electa, 2002

In course of publication

L. Pirzio Biroli Stefanelli, *La collezione Paoletti. Stampi in vetro per impronte di intagli e cammei, 1.* Rome, Gangemi

INDEX OF ARTISTS

Filippo Agricola
Rome 1795 - 1857

Gioachino Altobelli
Terni 1814 - Rome c. 1879

Paolo Anesi
Rome 1697 – 1773

Pompeo Girolamo Batoni
Lucca 1708 – Rome 1787

Pietro Berrettini, known as **Pietro da Cortona**
Cortona 1596/1597 – Rome 1669

Filippo Bigioli
San Severino Marche, Macerata 1798 – Rome 1878

Alexei Petrovich Bogolyubov
Pomeranian village, government of Novgorod 1824 – Paris 1896

Giuseppe Bottani
Cremona 1717 – Mantua 1784

Pietro Bracci
Rome 1700 - 1773

Ippolito Caffi
Belluno 1809 – Lissa 1866

Bernardino Cametti
Rome c. 1669 – 1736

Antonio Canova
Possano, Treviso 1757 – Venice 1822

L. Caracciolo
active in the early nineteenth century

Giuseppe Ceracchi
Rome 1751 – Paris 1801

Giuseppe Bartolomeo Chiari
Lucca or Rome 1654 – Rome 1727

Viviano Codazzi
Bergamo (?) c. 1606 – Rome 1670

Antonio D'Alessandri
Paolo Francesco D'Alessandri
active in Rome from 1855 to 1880

Filippo Della Valle
Florence 1698 – Rome 1768

Abraham-Louis-Rodolphe Ducros
Meudon 1748 – Lausanne 1810

François Du Quesnoy known as **Fiammingo**
Brussels 1597 – Livorno 1643

Teodoro Fabbri
active in Rome from 1887 to post 1911

Fegatti ?
Active in Rome in the first half of the nineteenth century

Giovanni Ferri, known as **Giovanni Senese**
active from 1621 to 1634

Pietro Fontana
Bassano 1762 – Rome 1837

Heinrich Fussli
Zurich 1741 – Putney Heath 1825

Gaspare Gabrielli
active in Rome and Dublin in the first quarter of the nineteenth century

Filippo Gagliardi known as **Filippo Bizzarro** or **Filippo delle Prospettive**
Rome 1606/1608 - 1659

Pietro Gagliardi
Rome 1809 – Frascati, Rome 1890

Francesco Gai
Rome 1835 – 1917

Giovan Battista Gaulli known as **Baciccio**
Genoa 1639 – Rome 1709

Pier Leone Ghezzi
Rome 1674 – 1755

Giuseppe Girometti
Rome 1779/1780 – 1851

Pietro Girometti
Rome 1812 – 1859

John Goldicutt
London 1793 – 1842

Domenico Guidi
Torano di Carrara 1625 – Rome 1701

Gavin Hamilton
Murdierston House, Lanarkshire, Scotland 1723 – Rome 1798

Robert Havell
active in London in the first half of the nineteenth century

Cristopher Hewetson
Kilkenny circa 1739 – Rome 1798

Hubert
active at the end of the eighteenth century

François (Franz) Keisermann
Verdon 1765 – Rome 1833

Pietro Labruzzi
Rome 1738 – 1805

Filippo Lauri
Rome 1623 – 1694

Henri Le Lieure De l'Aubepin
Nantes 1831 – Rome 1914

Ottavio Leoni
Rome 1578 – 1630

Vincent Leckerbetien known as **Manciola** or **Manicola**
Antwerp c. 1600 – 1650

Manciola (see Vincent Leckerbetien)

Adrien Manglard
Lyons 1695 – Rome 1760

Carlo Maratti
Camerino, Ancona 1625 – Rome 1713

Agostino Masucci
Rome 1690/1691 – 1768

J.Merigot
active in London between the late eighteenth century and early nineteenth century

Francesco Paolo Michetti
Tocco Casauria 1851 – Francavilla a Mare 1929

Nicola Michetti
Rome 1672/1681 – 1759

Francesco Mochi
Montevarchi 1580 – Rome 1654

Gaspare Mola (Molo or Moli)
Breglia, Como 1567/1571 – Rome 1640

Paolo Monaldi
Rome circa 1750 – 1800

Raffaello Morghen
Naples 1758 – Florence 1833

John Newbolt
London 1805 – active in Rome until 1868

Bernardino Nocchi
Lucca 1741 – Rome 1812

Lorenzo Ottoni
Rome 1648 – 1736

Michel Angelo Pacetti
Rome 1793 – 1865

Giovanni Paolo Panini
Piacenza 1691 – Rome 1765

Bartolomeo Pinelli
Rome 1781 – 1835

Benedetto Pistrucci
Rome 1784 – Englefield Green, UK 1855

Elena Pistrucci
1822 – 1886

Maria Elisa Pistrucci
1824 – 1881

Francesco Podesti
Ancona 1800 – Rome 1895

Simone Pomardi
Monte Porzio 1757 – Rome 1830

Luigi Primoli
Paris 1858 – Rome 1925

Samuel Prout
Plymouth 1783 – Camberwell 1852

Johan Reder
Rome 1656 – 1764

Francesco Righetti
Rome 1749 – 1819

Luigi Righetti
Rome 1780 – 1852

Domenico Rocchi
Active in Rome from 1856 to circa 1866

Pierre Ronche
Active second half of the seventeenth century

Hubert Robert
Paris 1733 – 1808

John Ruskin

London 1819 – Brantwood 1900

Andrea Sacchi
? 1559/1600 – Rome 1661

Agostino Tassi
Ponzano Romano c. 1580 – Rome 1644

Bertel Thorvaldsen
Copenhagen 1768/1770 – 1844

Teresa Tibaldi
Rome 1720 ? – 1776

Stefano Tofanelli
Nave, Lucca 1752 – Rome 1812

Giovanni Tognoli
Bieno, Trento 1786 – Rome 1862

Antoine-Jean-Baptiste Thomas
Paris 1791 – 1834

Johann Heinrich Troll
Winterthur 1756 – 1824

Willelm II Van Nieulandt
Antwerp 1584 – Amsterdam 1635

Jacob van den Vliete, known as **Jacopo della Riviera** or **Giacomo de la Rivière**
Audenarde, Flanders ? – Rome 1639 ?

Enrico Verbaschi
Active in Rome from circa 1860 to 1877

Jacob Ferdinand Voet or Vouet
Antwerp 1639 – Paris 1689

Giovanni Volpato
Angarano di Bassano 1735 – Rome 1803

PRINTED ON DECEMBER 2002
VARIGRAFICA ALTO LAZIO sas DA IMPIANTI TIPOLITOGRAFICI
GANGEMI EDITORE – Rome